Drawing Animals

Art for everyone!

Written by
Carolyn Scrace

Illustrated by
Carolyn Scrace
and Mark Bergin

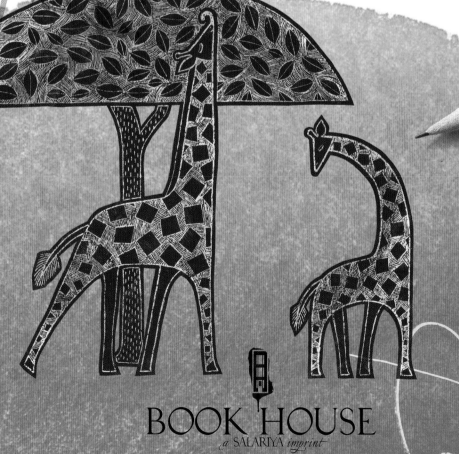

BOOK HOUSE
a SALARIYA *imprint*

Published in Great Britain in MMXX by
Book House, an imprint of
The Salariya Book Company Ltd
25 Marlborough Place, Brighton BN1 1UB
www.salariya.com

ISBN: 978-1-912904-43-3

SALARIYA
SCRIBO BOOK HOUSE SCRIBBLERS

1 3 5 7 9 8 6 4 2

A CIP catalogue record for this book is available
from the British Library.

Printed and bound in China.

Visit
www.salariya.com
for our online catalogue and
free fun stuff.

Author: Carolyn Scrace
Artists: Carolyn Scrace and Mark Bergin
Additional illustrations by:
David Antram and Isobel Lundie
Editor: Nick Pierce

Photo credits: Shutterstock

PAPER FROM
SUSTAINABLE
FORESTS

Adult supervision is advised
for some of these projects.

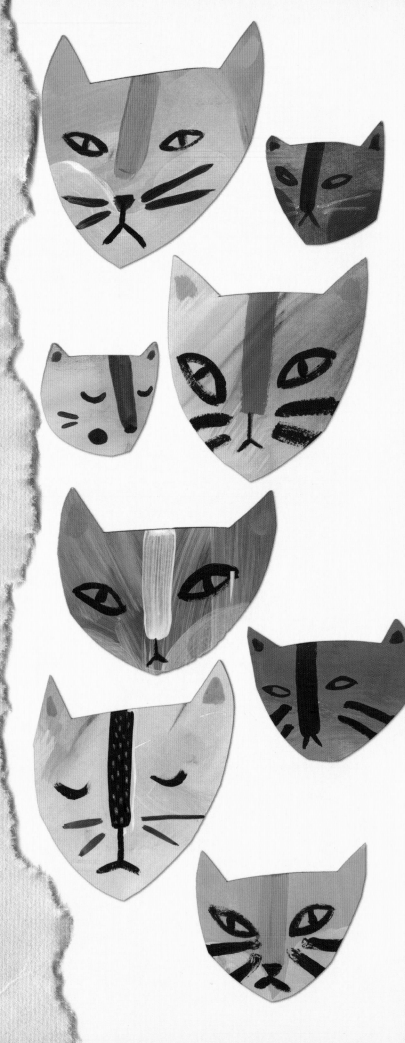

Contents

4 Materials	36 Stencil printing 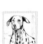
6 Ink washes	38 Painted stones
8 Soft pastels	40 Paper mosaic
10 Pencil crayon	42 Drawing from
12 Wax resist	a photograph
14 Simple shapes	44 Etching
16 Paper collage	46 Paper cups
18 Handprints	48 Drawing lions
20 Painting shapes	50 Watercolour
22 Experiment	52 Different style
24 Line and wash	54 Movement
26 Torn paper	56 Computer
28 Sketching	58 Inspiration 1
30 Paper folding	60 Inspiration 2
32 Relief printing	62 Glossary
34 Tissue collage	64 Index

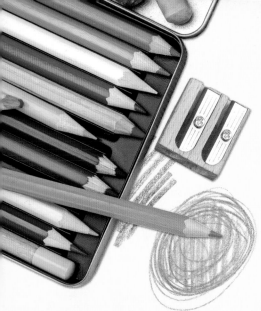

Pictures of the materials you will need to complete each project can be found at the beginning of each activity throughout this book.

Coloured pencil crayons

These are ideal for colouring in pictures. Try layering darker colours on top of lighter ones to create shading and depth.

Materials

Here are some of the materials that have been used in this book. They can be purchased from most art supply shops and stationers. Experiment with different art materials to find out which ones you most enjoy using.

Pens

Try drawing animals using marker pens, felt-tip pens or fineliner pens. Permanent ink felt-tip pens are ideal for drawing on most surfaces and don't run if wet paint is applied.

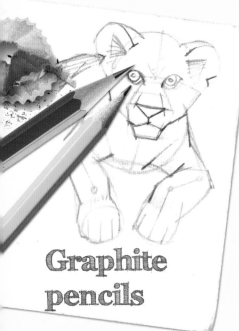

Graphite pencils

Use pencils for drawing and sketching. They are ideal for drawing and planning projects.

What you will need:

Pencil	Crayons	Paper
Paints	Scissors	Sponge
Tape	Ink	Spoon
Stones	Glue	Paintbrush
Coloured paper	Acrylic paint	Soft pastels
Paper cups	Wax crayons	Felt-tip pen
Fineliner pen	Polystyrene sheet	Roller
Pipe cleaners	Craft knife	Old baking tray
Tissue paper	Block printing colour	White gel pen

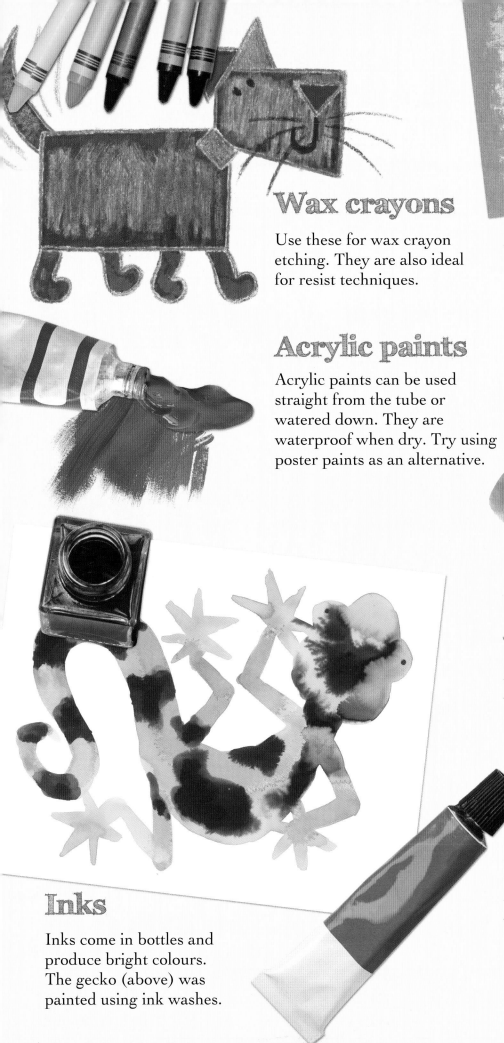

Wax crayons

Use these for wax crayon etching. They are also ideal for resist techniques.

Soft pastels

Soft pastels come in stick form. Try drawing with them on coloured paper. They are ideal for smudging and creating soft effects.

Acrylic paints

Acrylic paints can be used straight from the tube or watered down. They are waterproof when dry. Try using poster paints as an alternative.

Watercolour paints

Watercolour paints come in bottles, blocks or tubes. Mix them with water before using.

Inks

Inks come in bottles and produce bright colours. The gecko (above) was painted using ink washes.

Block printing colour

Use water-soluble block printing colour for making relief prints, as you can clean the printing block for re-use.

Ink washes
Experimental technique

A coloured ink wash is ink that has been thinned down with water and then applied to a sheet of paper. Washes can be flat or varied in tone and can combine different colours. Use washes to create exciting and unexpected results. First try painting a wash onto dry paper. Then experiment by wetting the paper with a sponge and adding a contrasting colour to the damp paper.

1 Use a sponge to wet a sheet of watercolour paper. Dip a large paintbrush into brightly-coloured ink and paint the cat's head, body, legs and tail.

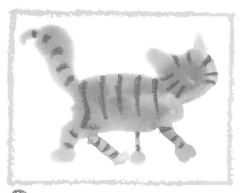

2 When the ink is completely dry, use a wax crayon to draw in the cat's stripes.

3 Use black pencil crayon to draw in the cat's eyes, nose, mouth and whiskers. Then draw in his paws.

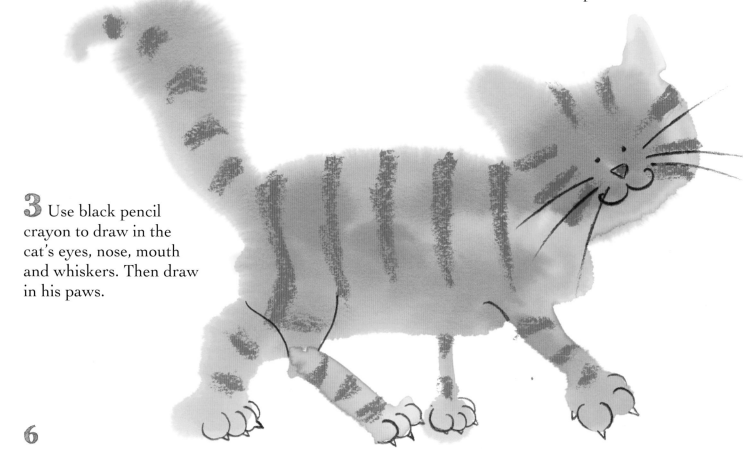

Ink wash gecko

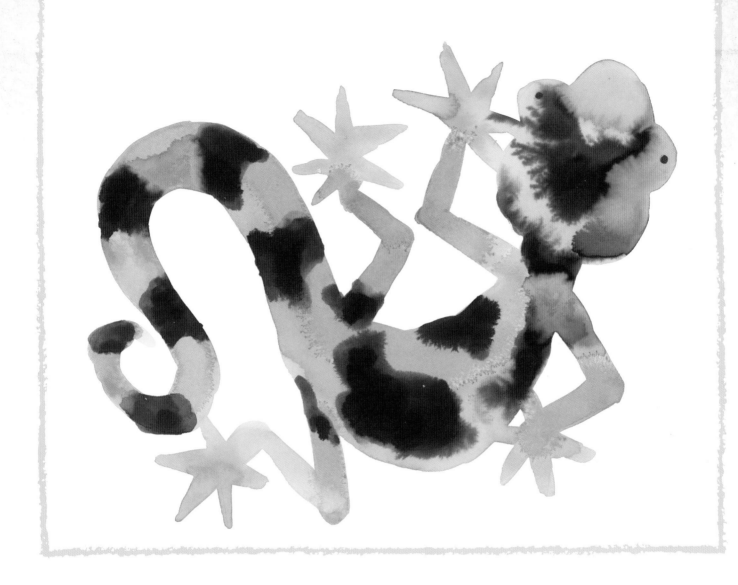

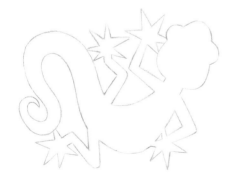 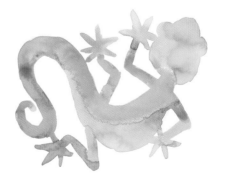 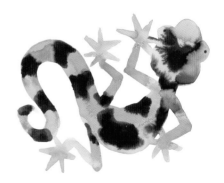

1 A gecko shape is more complicated, so draw its outline onto watercolour paper. Use a pale blue crayon.

2 Use a brush to paint the whole gecko with pale blue ink. Add a line of green ink down the back areas and its legs.

3 While the ink is still wet, add some stripes and patches using dark blue ink.

Soft pastels

Soft pastels are good for creating soft, smudged effects. Experiment by drawing on darker-coloured paper with light-coloured pastels.

1 Draw a rabbit with a white soft pastel. The drawing is made up of simple oval and sausage shapes.

2 Now use a brown pastel to draw spots on the rabbit's back, face and on one ear. Use a pink crayon to draw in the nose, mouth and other ear.

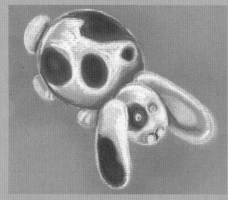

3 Add black to the brown spots and smudge them. Put in areas of shading using a grey soft pastel. Blend and smudge colours with your fingertip.

Smudging technique

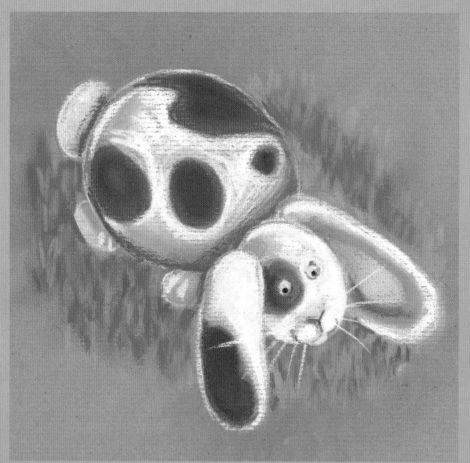

4 Use a black pastel to add dots to the eyes and to define the nose. Add white whiskers. Lightly smudge in two shades of green for the grass.

Different effects

Try using the side edges of soft pastels to make broad strokes of colour. The sharp ends are ideal for bold lines. Use pointed corners for adding any fine details.

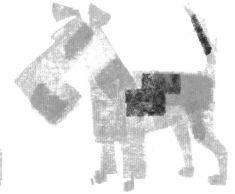

1 Use the side edge of a pastel to make rectangular shapes for the dog's body, neck and head. Use the tip to draw in its paw shapes.

2 Use the side edge of the pastel to make a series of lines for the tail. Use the end to draw in the dog's ears.

3 Use different-coloured pastels to make patches on the dog's face, body and tail.

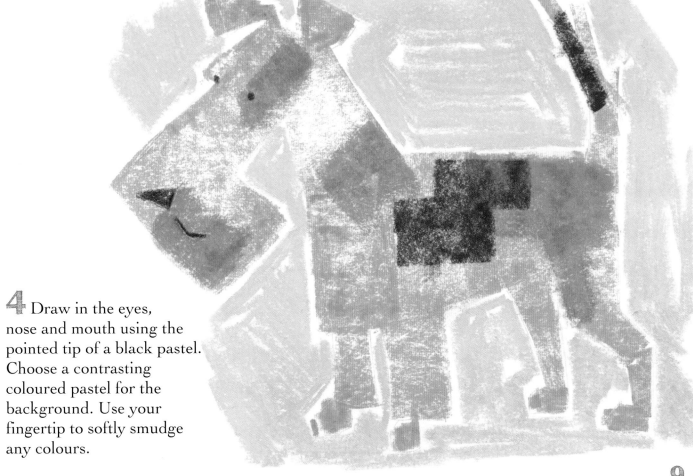

4 Draw in the eyes, nose and mouth using the pointed tip of a black pastel. Choose a contrasting coloured pastel for the background. Use your fingertip to softly smudge any colours.

Pencil crayon

When using pencil crayons, you will find that if darker colours are layered on top of lighter ones it creates richer tones and added texture.

Crayon techniques

Press lightly with your crayon to make pale colours.

By pressing down harder you can make darker colours.

Try layering different colours.

Try crayon scribbling.

Try layering different colours.

Try criss-crossing different-coloured lines.

Crayon dinosaur

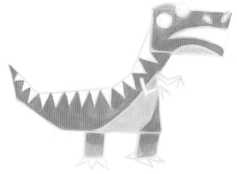

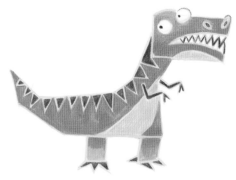

1 Use a yellow pencil crayon to draw in a dinosaur. Use simple shapes to construct your dinosaur.

2 Use a pale yellow crayon to colour in the main shapes. Go over parts of it (as shown) with an orange pencil crayon.

3 Use a dark green pencil crayon to add details and to colour in the pattern.

Watercolour crayons

Use watercolour crayons to draw, as you would with a pencil or crayon. Then use a wet brush to paint over your drawing. The colours will disperse and turn into a watercolour wash. To create soft effects for clouds and skies, try lightly scribbling with watercolour crayons before painting with water.

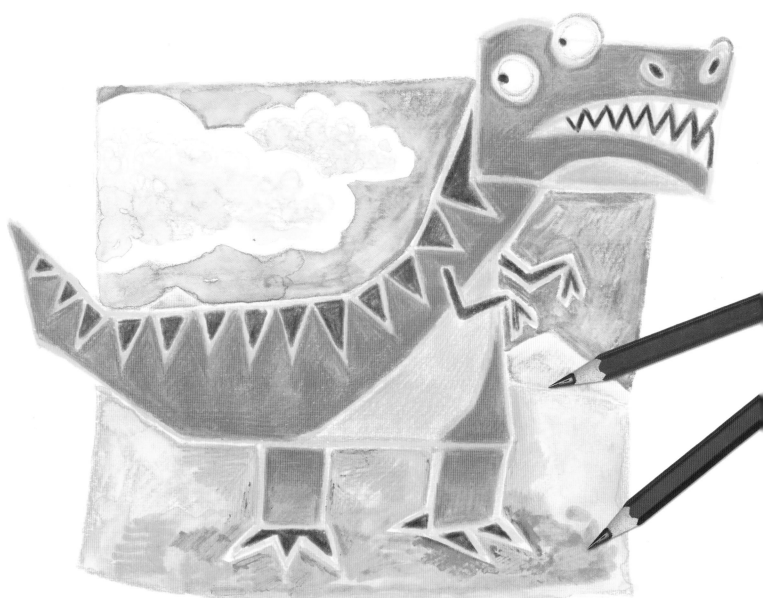

4 Using watercolour crayons, lightly sketch in the background. Now dip a clean brush in water and wet the background area. Leave to dry.

Wax resist

O il and water don't mix. So when painting with ink or using water-soluble felt-tip pens, you can use oily wax crayons to mask out areas of the paper to keep it white.

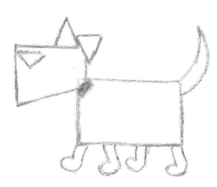 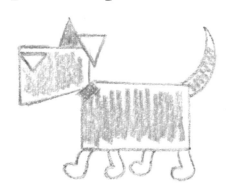

1 Use a bright blue wax crayon to draw a dog using simple shapes. Make the wax line thick and bold.

2 Roughly scribble in some fur over the head, body and tail using a grey wax crayon.

3 Use a black felt-tip pen to colour in the dog's body, head, tail and legs.

4 Use a black wax crayon to draw in the eyes, mouth and whiskers.

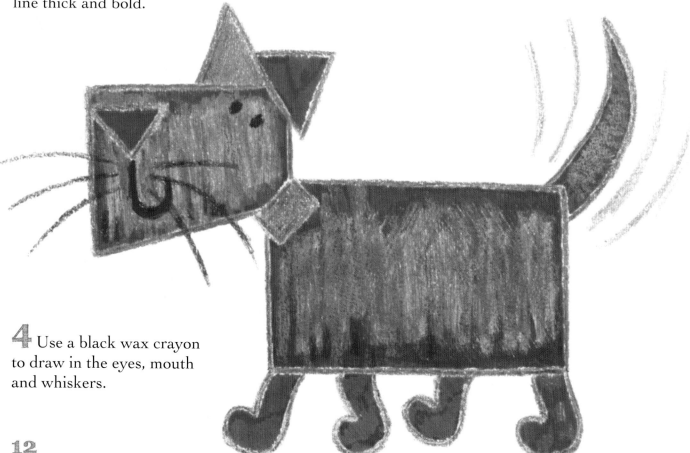

1 Lightly pencil in the shape of a dog. Draw over all the lines with a white wax crayon. Make the wax line strong and bold.

2 Use a large paintbrush to paint the whole dog with clean water. While the paper is wet, paint in pale blue, black and pink ink (as shown).

3 Leave to dry. Then use a white wax crayon to draw in a border. Paint in the background with a blue ink wash.

4 Using a black wax crayon, draw in the mouth and add dots to the eyes. Draw in its paws.

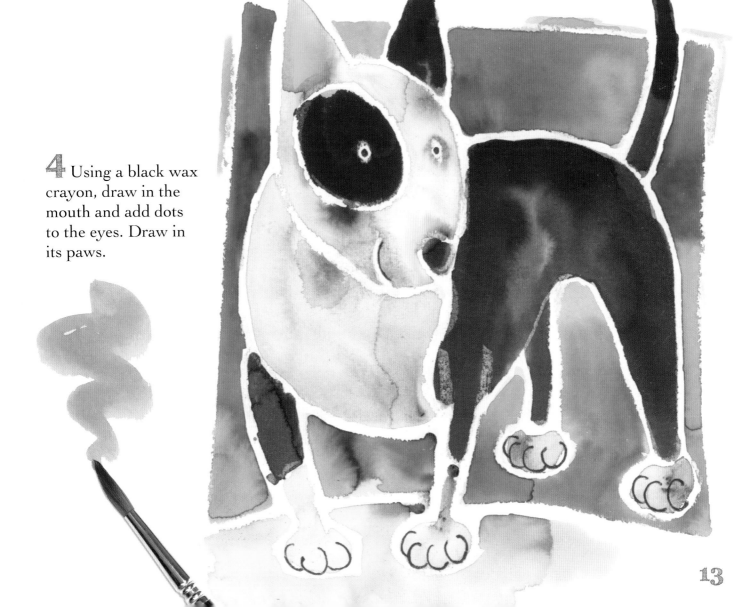

13

Simple shapes

When drawing any animal it is important to begin by studying it. Look at and compare the size and shape of its head, body, legs and arms (if it has any). Note how each part is attached to the body. Look at any other distinguishing features, such as tails and ears.

Giant anteater

1 Draw in the curved shape of the anteater's head, body and tail.

2 Note the position of the two sturdy back legs and pencil in.

3 Draw in both front legs. Note how its claws curl backwards.

4 Add an eye, ear and a nostril. Draw the shape of its back and its markings. Colour in.

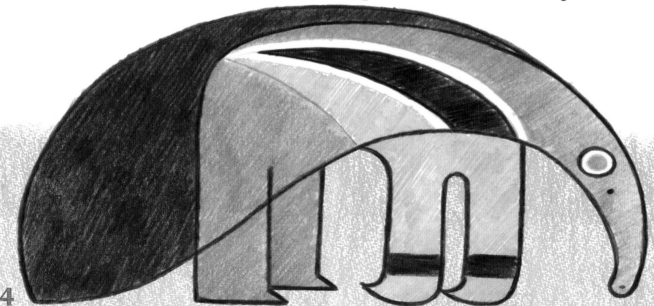

Nine-banded armadillo

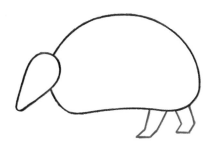

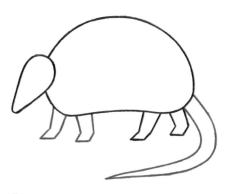

1 Draw in the shape of the armadillo's head and body.

2 Pencil in two short back legs and its feet.

3 Draw in the armadillo's two front legs and its long tail.

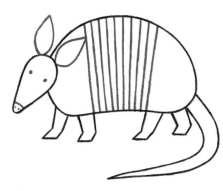

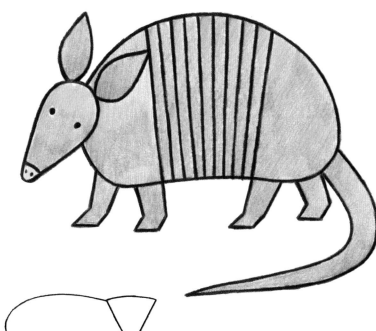

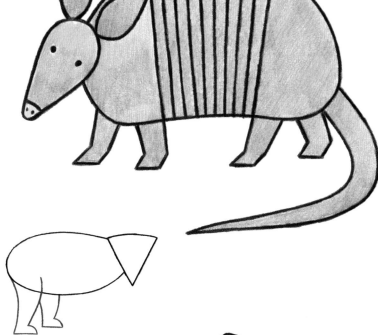

4 Add its ears, eyes and nose. Draw in nine bands. Colour in.

Coati

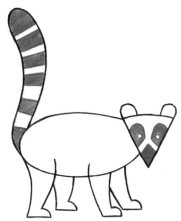

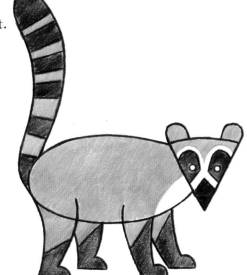

1 Draw a triangle for the coati's head and an oval for its body.

2 Pencil in its back legs and feet.

3 Draw in its front legs and feet and a long upright tail.

4 Draw in its ears. Add its eyes, nose and tail markings.

5 Colour in.

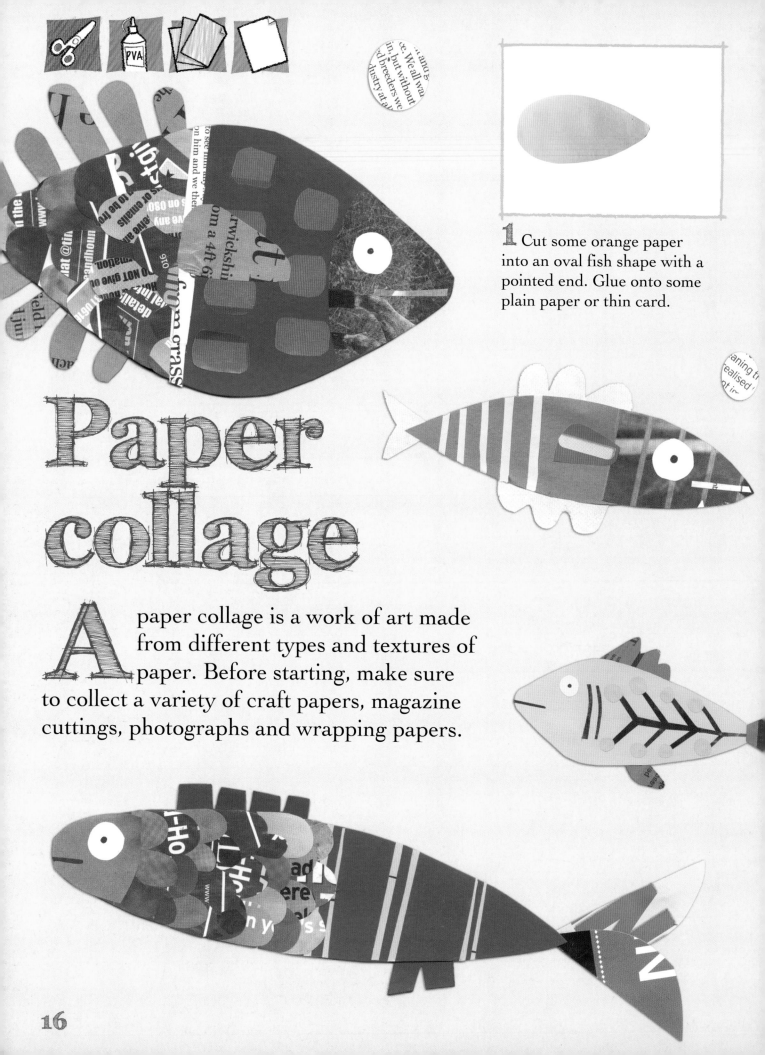

Paper collage

1 Cut some orange paper into an oval fish shape with a pointed end. Glue onto some plain paper or thin card.

A paper collage is a work of art made from different types and textures of paper. Before starting, make sure to collect a variety of craft papers, magazine cuttings, photographs and wrapping papers.

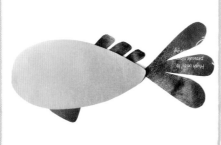

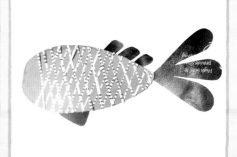

2 Cut a fan-shaped tail out of dark blue magazine pages. Glue in place.

3 Using the same magazine pages, cut out and stick on four fins.

4 Cut thin strips of newspaper. Stick onto the body to make a criss-cross pattern.

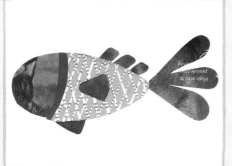

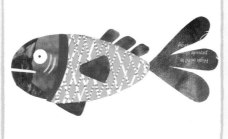

5 Cut out the head shape and two more fins in a contrasting colour. Glue in place.

6 Finally, cut out the fish's eye, mouth and gill shapes. Glue in place.

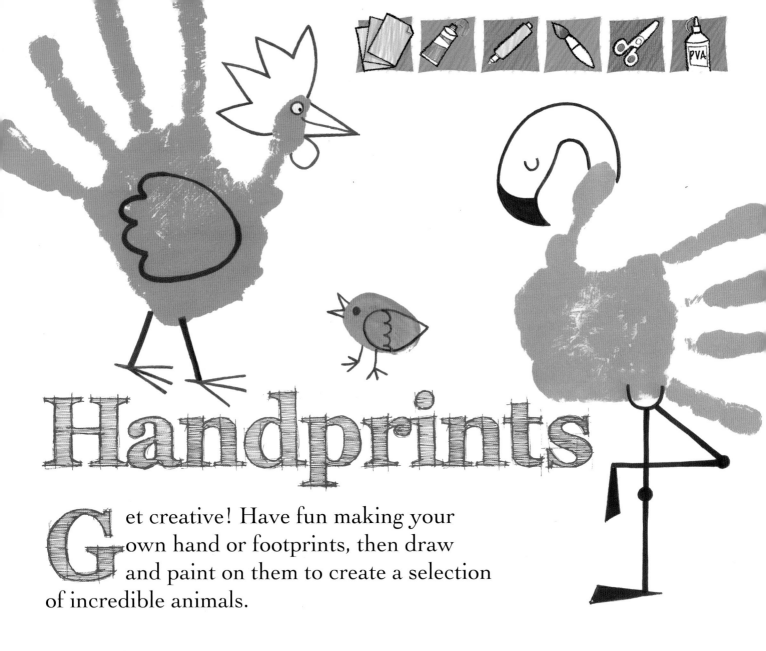

Handprints

Get creative! Have fun making your own hand or footprints, then draw and paint on them to create a selection of incredible animals.

Elephant

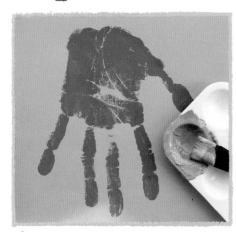

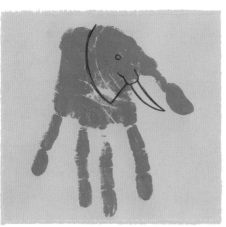

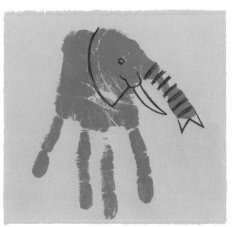

1 Paint your hand with poster paint and press down onto paper. Leave to dry.

2 Study the shape of your handprint. Use a black felt-tip pen to draw in an elephant's ear, eye and tusk.

3 Draw in the end of the elephant's trunk and add fold lines.

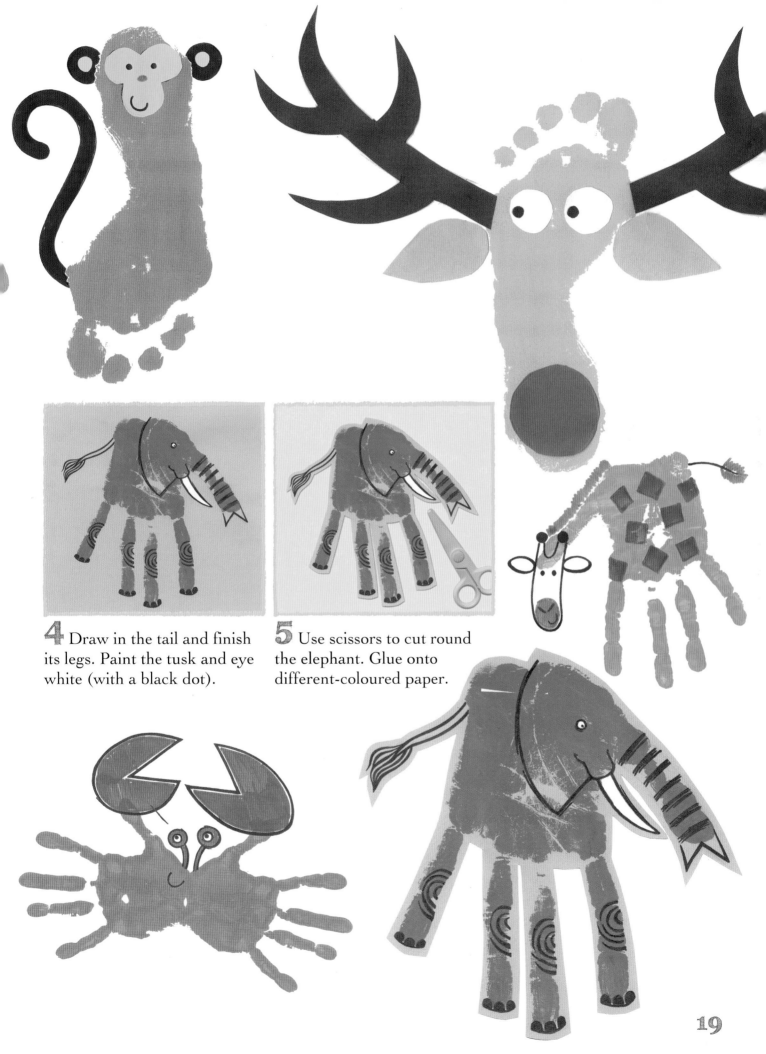

4 Draw in the tail and finish its legs. Paint the tusk and eye white (with a black dot).

5 Use scissors to cut round the elephant. Glue onto different-coloured paper.

19

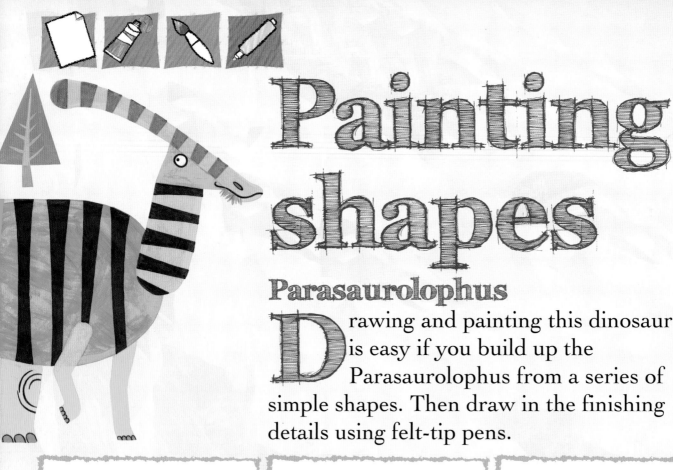

Painting shapes

Parasaurolophus

Drawing and painting this dinosaur is easy if you build up the Parasaurolophus from a series of simple shapes. Then draw in the finishing details using felt-tip pens.

1 Study the shape of the Parasaurolophus. Use poster paint or acrylics to paint an oval for its body.

2 Paint in a triangle for its head, then add a sausage shape for its neck.

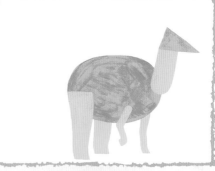

3 Paint in two thick rectangles for its back legs and two thinner front legs.

4 Paint in a large triangle for its strong tail.

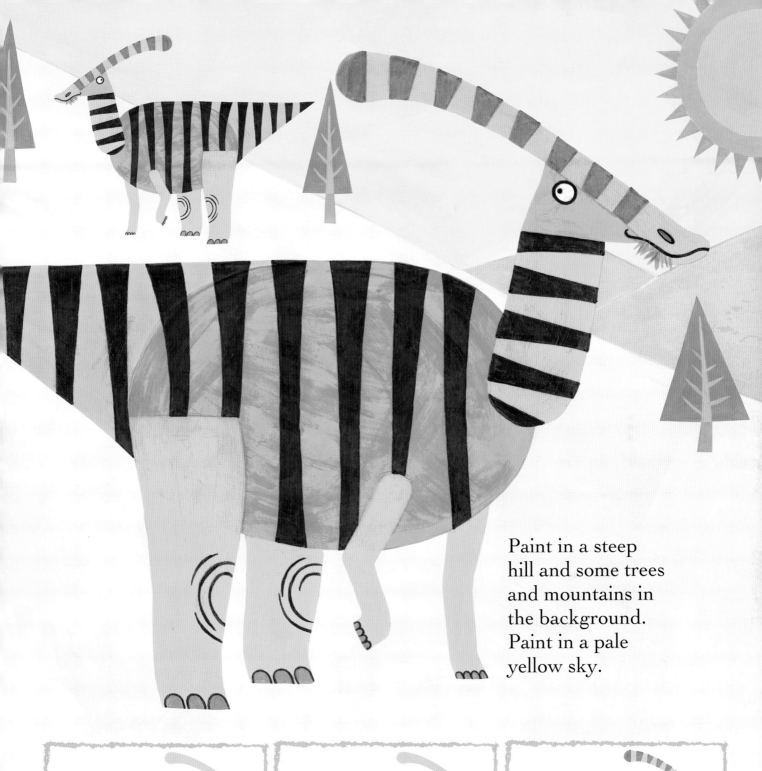

Paint in a steep hill and some trees and mountains in the background. Paint in a pale yellow sky.

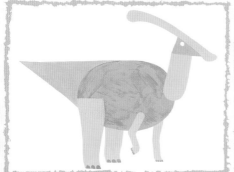

5 Paint in a long curved shape for its head crest. Add toenails.

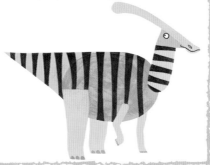

6 Use a black felt-tip pen to draw its eye, nostril and mouth. Add black stripes to its neck and body.

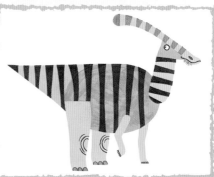

7 Paint grey stripes on the head crest. Use the black felt-tip pen to draw its knees and to outline its toenails.

21

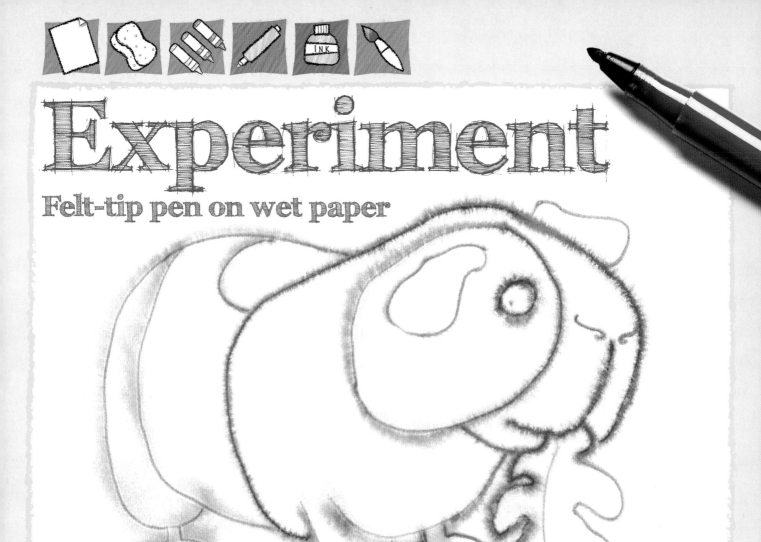

Experiment
Felt-tip pen on wet paper

1 Use a sponge to wet a sheet of watercolour paper. While the paper is still wet, draw in a guinea pig (as shown) using a felt-tip pen filled with water-soluble ink. Leave to dry.

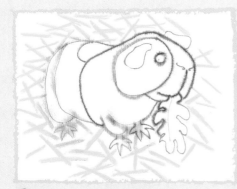

2 Go over all the white parts of the guinea pig with a white wax crayon. Use a yellow wax crayon to draw in its straw bedding (as shown).

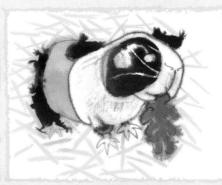

3 Use a sponge to wet the paper again. Paint the rest of the guinea pig's markings with coloured inks or watercolour paints. Paint in the leaf.

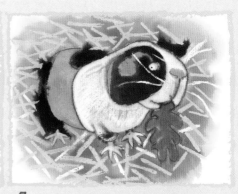

4 While the paper is still damp, paint over the guinea pig's bedding with greyish-yellow ink and leave the colours to bleed.

Painting onto damp paper creates a soft
finish to the edges of the picture.

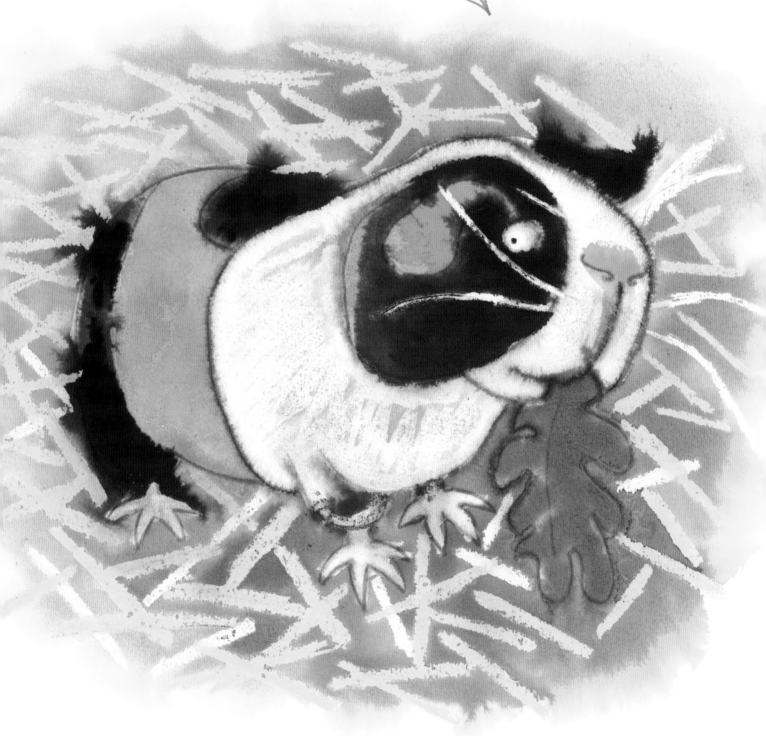

Once you have finished this picture, try other
experiments using wax crayons or oil pastels.
Remember, it's the wax or oil crayons that repels
the water. Use thick marks – or you can sharpen
the crayon points for thinner, more precise lines.

Line and wash

Line and wash is a technique that combines ink drawings with loose washes of colour. It's best to use waterproof ink pens, and either watercolour paints or coloured inks.

1 Pencil in a semi-circle for the chicken's body. Draw in an oval shape for its neck and a circle for its head.

2 Sketch in the chicken's legs and feet. Pencil in lines for its tail feathers.

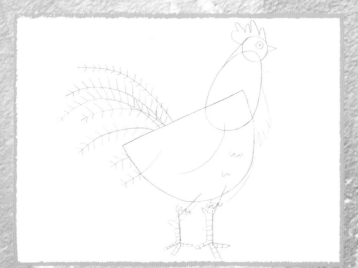

3 Pencil in its head comb, wattle, beak and eye. Finish drawing its legs and feet. Draw in the neck feathers and wing shape. Add detail to the tail feathers.

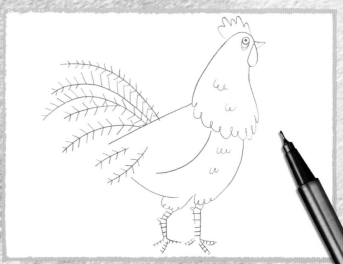

4 Now use a fine, black fineliner pen to ink in the drawing. Leave to dry. Erase pencil lines.

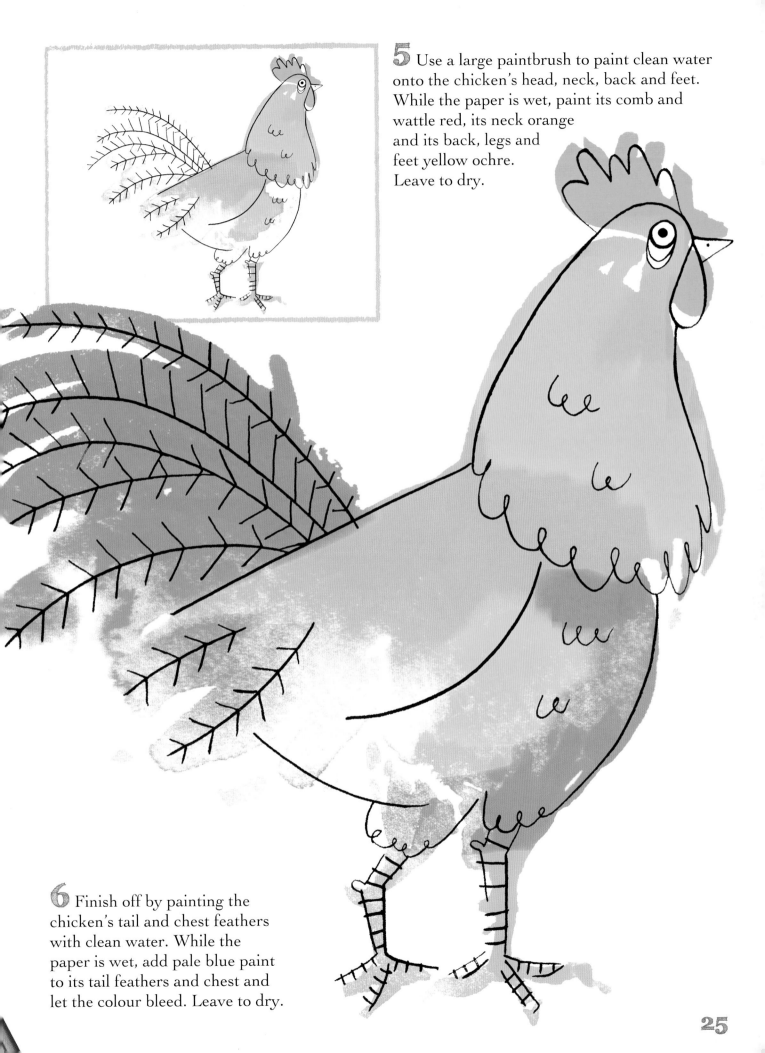

5 Use a large paintbrush to paint clean water onto the chicken's head, neck, back and feet. While the paper is wet, paint its comb and wattle red, its neck orange and its back, legs and feet yellow ochre. Leave to dry.

6 Finish off by painting the chicken's tail and chest feathers with clean water. While the paper is wet, add pale blue paint to its tail feathers and chest and let the colour bleed. Leave to dry.

25

Torn paper

Indenting technique

The secret of tearing paper accurately is to first indent the line along which you want to tear. You must press really hard with your pencil to indent the paper.

Draw simple shapes

1 Pencil in an oval for the goat's head and add two small ovals for its ears.

2 Draw a large semi-circle for its body. Add a small tail.

3 Draw in four thin leg shapes.

Indenting and tearing

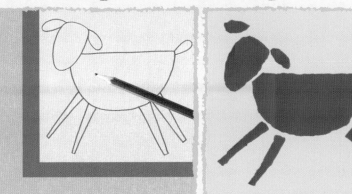 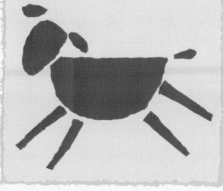 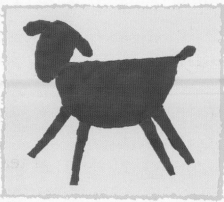

4 Place your drawing onto brown-coloured paper and draw over each individual shape. Press hard!

5 Tear out each of the indented shapes: the head, ears, body, legs and tail.

6 Glue the body onto coloured paper. Now glue on all the other shapes.

Use torn white paper for the eyes, horns, beard, tummy and hooves. Glue in place.

Tear out two pink shapes for the goat's ears and another for its nose. Glue them in place.

Use a fine-nibbed, black felt-tip pen to add dots for the eyes and nostrils. Then add ridges to its horns and finish off its hooves.

Sketching

Using simple shapes

Dinosaurs and other animals can be difficult to sketch and draw. It is important to study them first to try and simplify their overall shape into a series of simple geometric shapes.

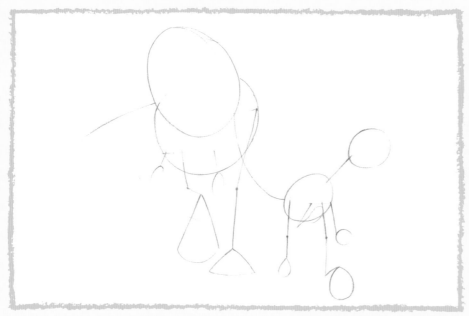

1 Pencil in a large oval for the big dinosaur's head and a circle for its body. Draw ovals for the head and body of the smaller dinosaur. Pencil in lines to indicate the direction and position of their legs and arms. Use triangles or ovals for their feet.

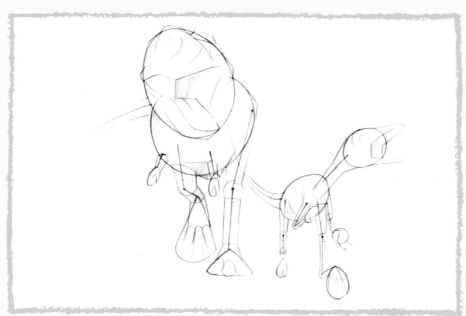

2 Note the angles for each head. Draw in the shape of each dinosaur's mouth and jaw. Mark in the position and shape of the eyes.

3 Start to sketch in the shape of the arms, legs and tails. Add detail to the hands and feet.

4 Finish drawing each dinosaur's head and eye. Finish off the mouths and add teeth. Finish sketching in the legs and add claws. Draw each dinosaur's hands and fingers. Add shading to darker areas and to create shadows on the undersides of each dinosaur.

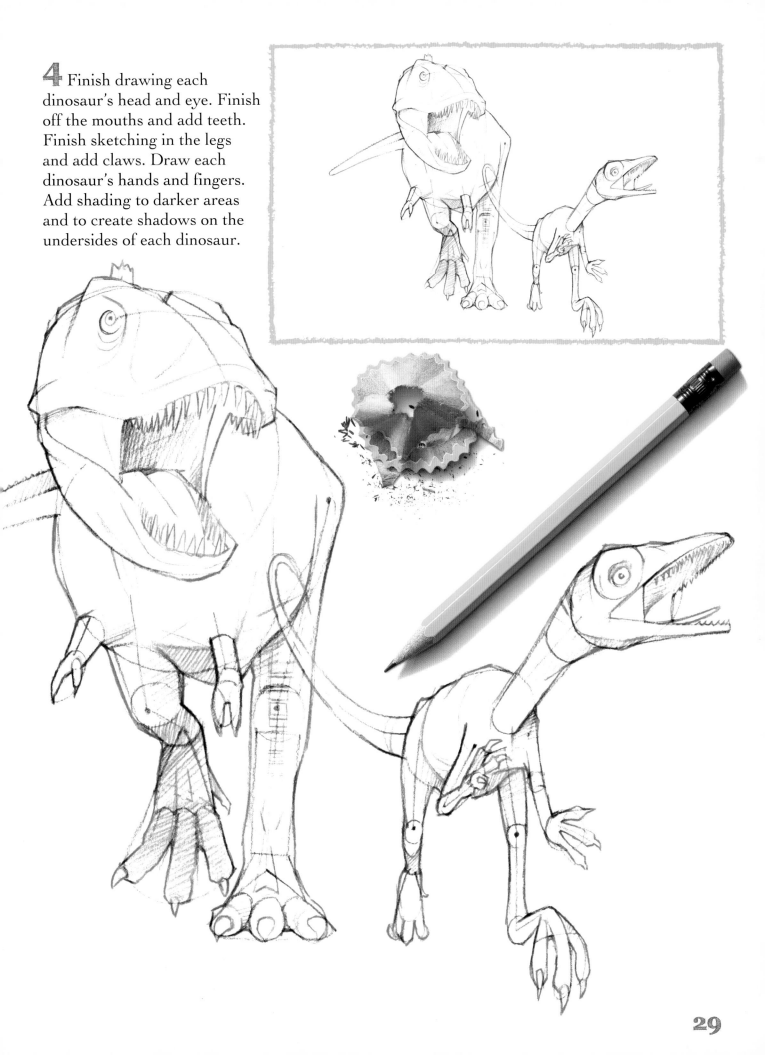

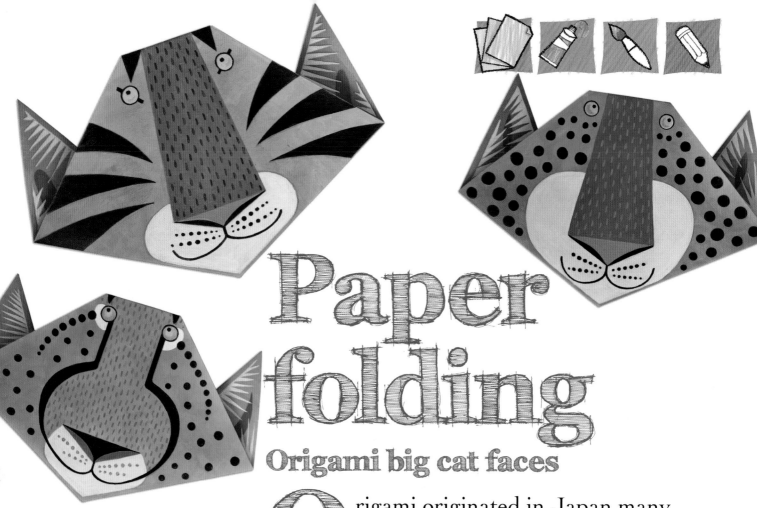

Paper folding

Origami big cat faces

Origami originated in Japan many years ago and is now popular all round the world. Origami is the technique of folding paper into amazing 3D shapes and models. To make each model you only need a square piece of paper and paint!

Make sure you use paper that is thin enough to fold easily.

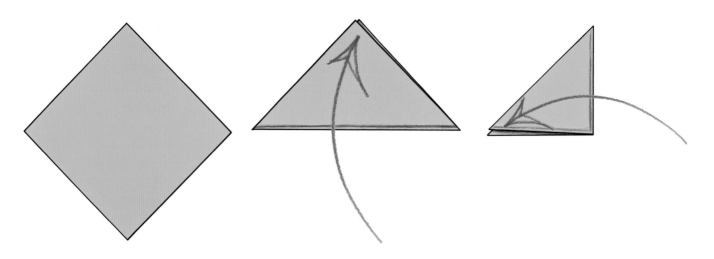

1 Take a square sheet of orange paper.

2 Fold the bottom corner up to the top corner (as shown). Crease.

3 Fold the right corner over to the left (as shown). Crease, then unfold.

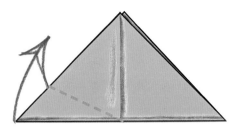 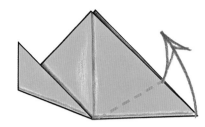 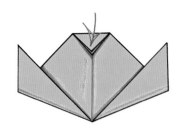

4 Fold the left corner up at an angle (as shown). Crease.

5 Fold the right corner up at an angle (as shown).

6 Fold the top point downwards (as shown).

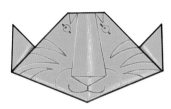 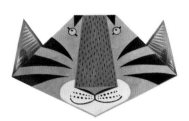

7 Now turn it over. Draw in the tiger's nose, eyes, mouth and snout. Add some stripes.

8 Paint the tiger's snout white and the section above it brown. Paint the stripes black.

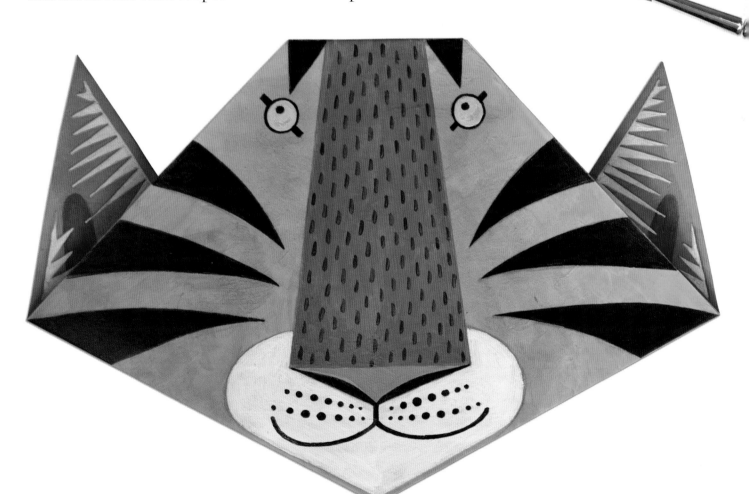

Use a fine paintbrush to paint in the tiger's eyes and ears. Paint in all the finishing details.

Try making more paper models to paint, like the leopard and cheetah (see top left).

Relief printing

Indent a polystyrene printing block with a design. Cover the printing block with block printing colour (water-soluble), lay a sheet of paper on top and press down. Peel off the paper with a reverse print of your design.

This is a super way of re-using polystyrene plates or packaging!

1 On paper, pencil in a semi-circle for the zebra's body. Draw in its head and neck.

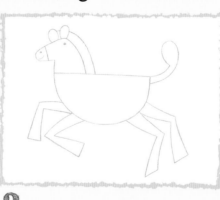

2 Draw in four leg shapes. Add its eye, ears, mane, snout and tail.

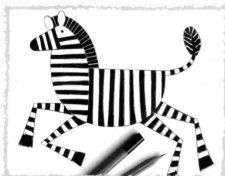

3 Use a black felt-tip pen to draw in all its stripes. Add its muzzle and hooves. Pencil over the back of the drawing.

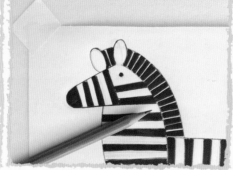

4 Tape the drawing onto a sheet of polystyrene. Go over all the lines again, pressing hard with the pencil.

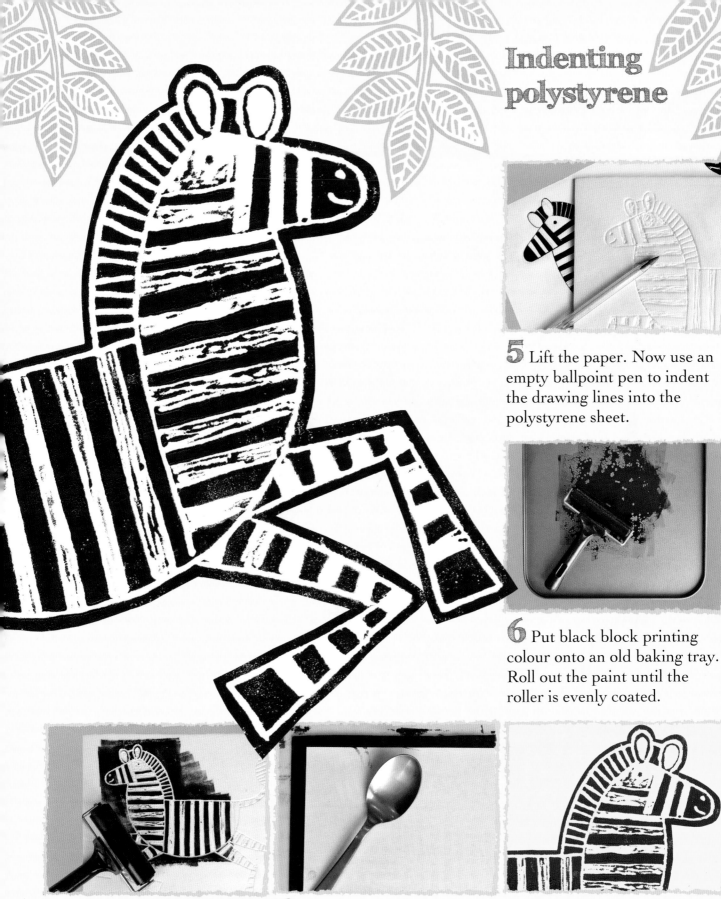

5 Lift the paper. Now use an empty ballpoint pen to indent the drawing lines into the polystyrene sheet.

6 Put black block printing colour onto an old baking tray. Roll out the paint until the roller is evenly coated.

7 Using the roller, quickly apply the colour over your polystyrene printing block.

8 Lay a sheet of paper on top of the printing block and use the back of a large spoon to burnish it. Carefully peel off the paper to see the finished print.

Wipe the printing block clean and re-use it to make more prints. Try printing with different-coloured paints onto coloured paper.

33

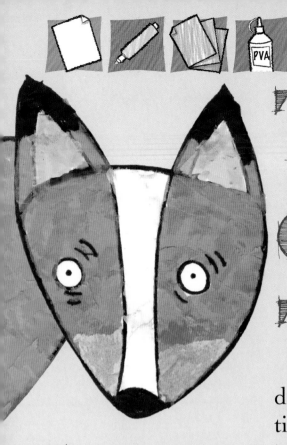

Tissue collage

Tissue paper is ideal for creating vivid collages. Use a single layer to produce subtle colours, and build up darker colours by adding additional layers of tissue paper.

1 Use a black felt-tip pen to draw the fox's head.

2 Draw in a long, sausage-shaped body.

3 Now draw in its front legs and a curve for the hind leg and foot.

4 Add the fox's ears and its long, bushy tail.

5 Now draw in small details like the eyes, nose and paws.

6 Tear the tissue paper into small pieces. Use PVA glue to stick them in place.

7 Tear small pieces of white tissue paper and glue on for the end of the fox's tail, its feet and its tummy. Add pale pink tissue to its ears and muzzle.

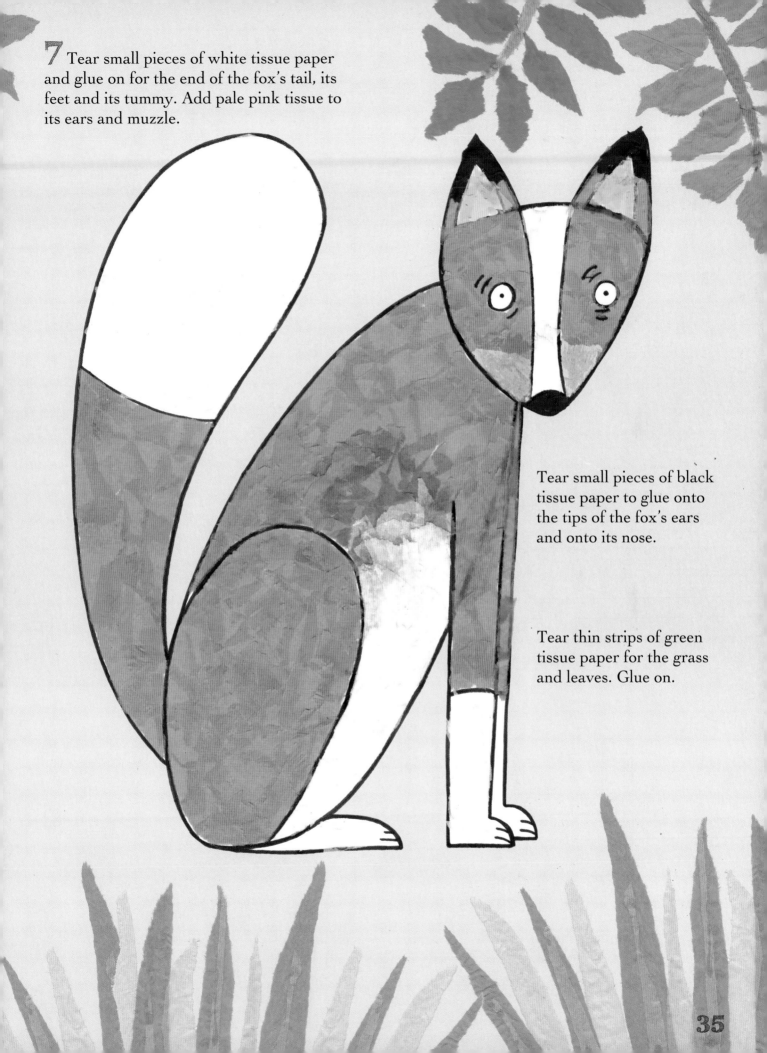

Tear small pieces of black tissue paper to glue onto the tips of the fox's ears and onto its nose.

Tear thin strips of green tissue paper for the grass and leaves. Glue on.

Stencil printing

Paper stencils produce bold prints and work best when used with strong, bright colours. Cut the stencils out of cartridge paper and print by dabbing paint through the cutaway shapes.

Making stencils

 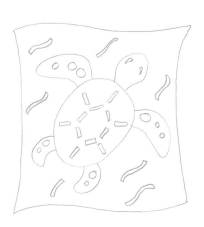 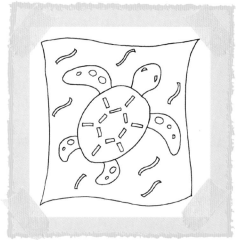

1 Draw a wavy border round a square sheet of paper. Pencil in an oval for the turtle's shell. Add its head and flippers.

2 Pencil in simple shapes for the markings on its shell and flippers. Add some wavy lines for the sea.

3 Take four more squares of paper all the same size. Carefully trace exact copies of the turtle drawing.

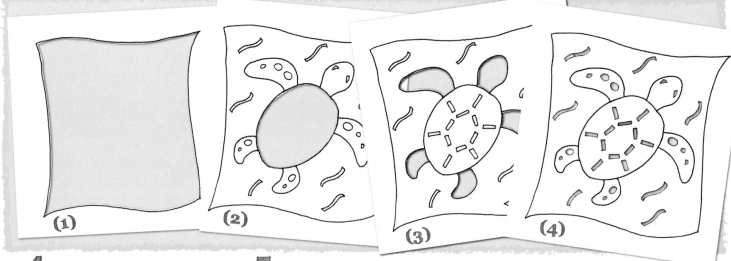

(1) (2) (3) (4)

4 Place stencil **1** on a piece of old cardboard. Use a craft knife to cut out the area inside the frame.

5 Stencil **2**: cut out the shape of the turtle's shell. Stencil **3**: cut out the head and flippers.

Stencil **4**: cut out the eyes, markings and the wavy lines for the sea.

36

Printing stencils

(1)

6 Tape stencil **1** onto a larger sheet of paper. Choose a colour for the sea. Use a large paintbrush to dab paint over the shape in the stencil. Carefully lift off the stencil and leave the print to dry.

Repeat step **6** with each remaining stencil, changing the colour for each stencil.

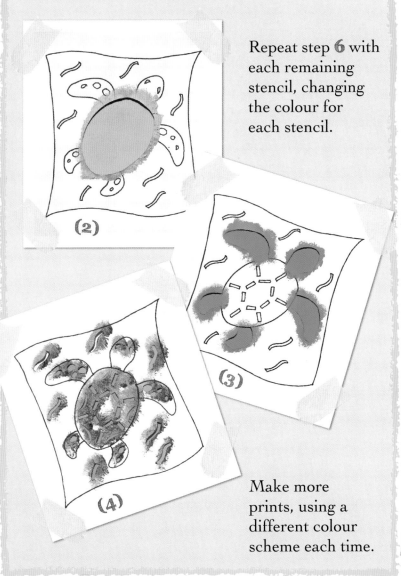

(2)

(3)

(4)

Make more prints, using a different colour scheme each time.

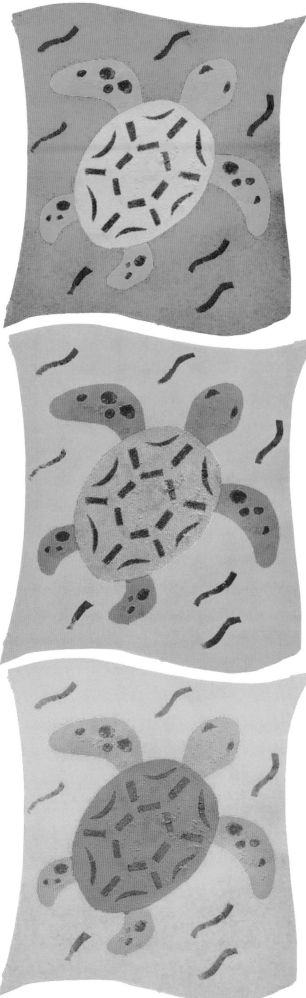

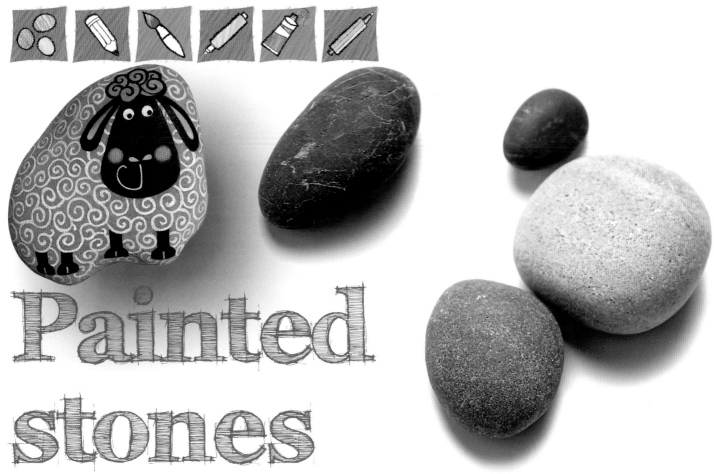

Painted stones

It's great fun to draw and paint on stones. Take inspiration from the shape and colour of each stone and then transform it into an animal of your choice. Hold the stone in your hand, feel its texture, study its curves and let its shape inspire your creativity.

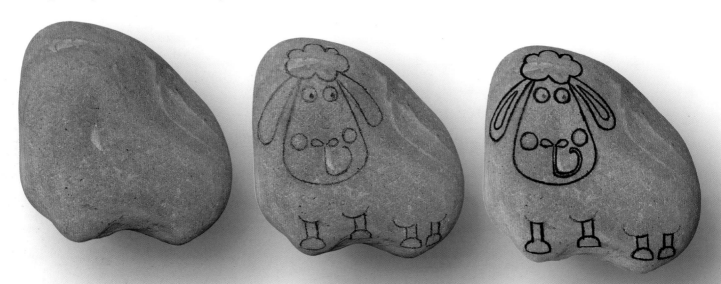

1 Choose a smooth, rounded stone. Turn the stone around to see which way best suits the shape of a sheep.

2 Pencil in the sheep's head. Draw in the curly fleece on top. Pencil in its ears, eyes, nostrils and mouth. Add its short legs and hooves.

3 Now go over the pencil lines with a black felt-tip pen.

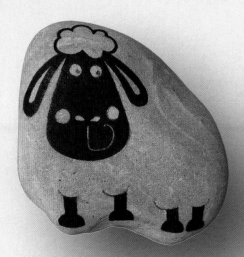 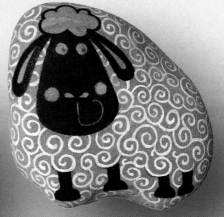 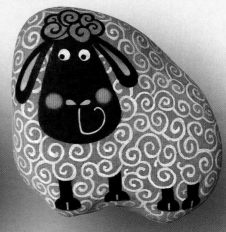

4 Use a black felt-tip pen (or black acrylic paint) to colour in the sheep's face, ears, legs and hooves (as shown).

5 Using a white gel pen, draw curly lines to look like the sheep's fleece.

6 Colour in the sheep's nostrils, cheeks and ears with pale pink acrylic paint. Use a white gel pen to draw in the eyes and the mouth.

More stones – why not paint a flock of sheep!

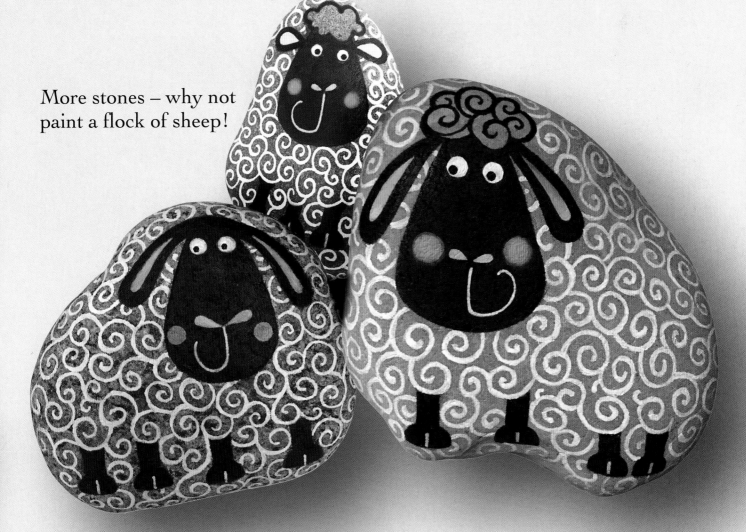

Paper mosaic

Traditional mosaics are made from small pieces of coloured tile or glass arranged together to create a pattern or image. Paper can be used to create similar effects.

1 Pencil an oval shape of a dinosaur's large head. Then draw in its body.

Mosaic dinosaur

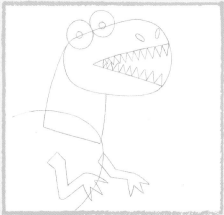

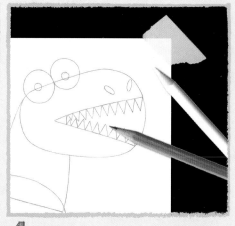

2 Now draw its neck and two small arms, each with three claws.

3 Pencil in the dinosaur's eyes, nostrils, mouth and teeth.

4 Scribble over the back of your drawing with a white crayon. Lay your drawing onto black paper and go over all the lines. Press hard.

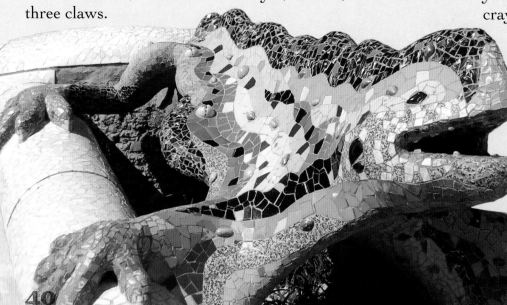

Mosaic lizard in Park Güell, Barcelona, Spain by Antoni Gaudí (1852–1926)

6 Cut out white paper triangles for the teeth. Use purple mosaics for the dinosaur's head, neck and back. Use blue and green mosaics for its throat and chest. Glue in place.

5 Cut out strips of coloured paper to cut into squares and triangles. Glue onto your drawing.

7 Cut around the shape, leaving a narrow black border round the mosaic (as shown). Glue your dinosaur mosaic onto some pale-coloured card.

Drawing from a photograph

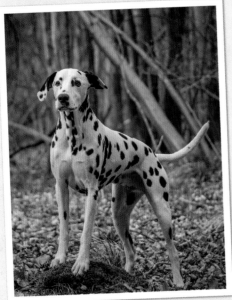

It is best to draw from life, but this is not always possible when drawing animals. Try using photographs instead. Choose a photograph that clearly shows an animal's face and body. Use the squaring-up technique (below) to help you copy your image and keep comparing your drawing to the photograph as you work. Study the animal's stance and the way it is holding its head, ears and tail. Use construction lines to help with the main shapes of the body and to position its limbs.

Squaring-up

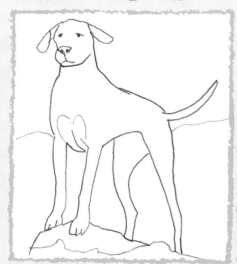

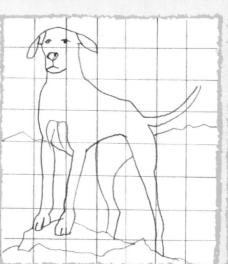

1 Using tracing paper, trace the outline of the animal in the photograph. Trace the main elements of the background.

2 Using a ruler, measure the width and height of the picture. Divide it into a grid of equal squares.

3 Draw the grid again on a sheet of cartridge paper. To enlarge your drawing, measure out a grid of larger squares.

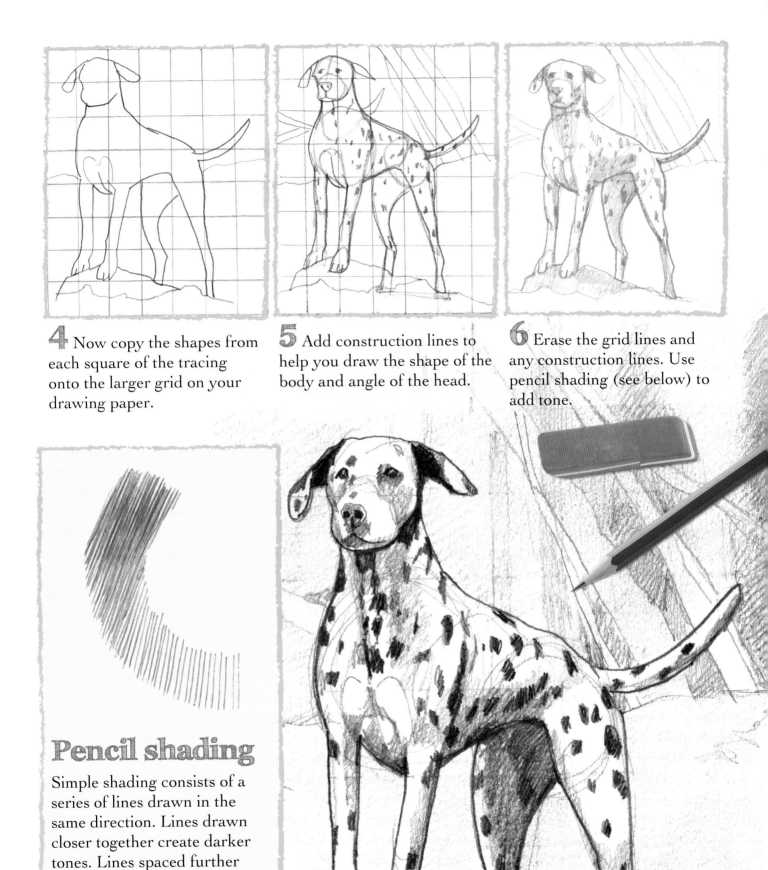

4 Now copy the shapes from each square of the tracing onto the larger grid on your drawing paper.

5 Add construction lines to help you draw the shape of the body and angle of the head.

6 Erase the grid lines and any construction lines. Use pencil shading (see below) to add tone.

Pencil shading

Simple shading consists of a series of lines drawn in the same direction. Lines drawn closer together create darker tones. Lines spaced further apart create lighter tones.

43

Etching

Wax crayon technique

Paper is first covered with wax crayoning, then painted in black poster paint and left to dry. A design is then etched (scratched) into the black paint. This reveals the colours of the wax crayoning beneath.

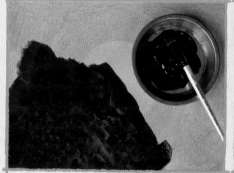

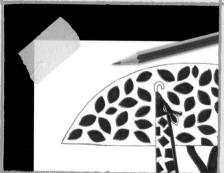

1 Draw simple shapes for the giraffes. Add squares for their markings. Draw a tree in the background.

2 Fill another sheet of paper of the same size with wax crayon patterning. Make sure to press firmly.

3 Using a large paintbrush, paint black poster paint over the wax crayoning. Leave to dry.

4 Tape your drawing on top of the black paint, then use a hard pencil to indent the design. Carefully remove the drawing.

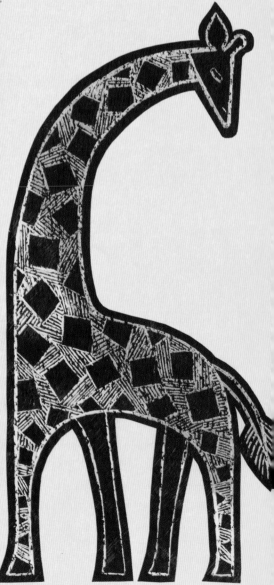

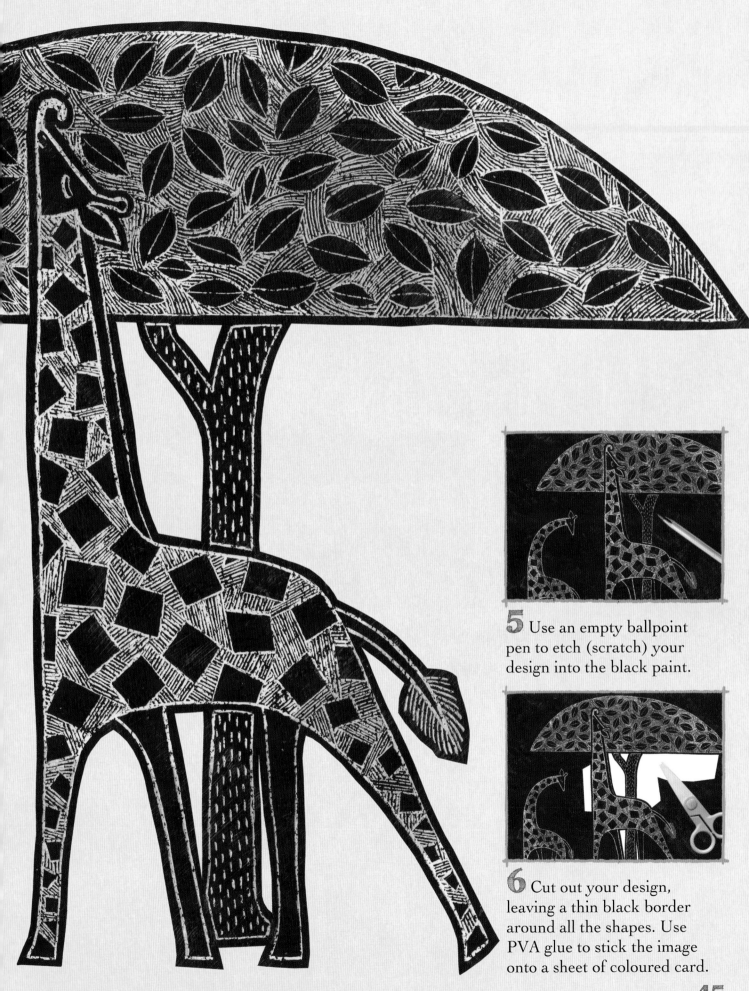

5 Use an empty ballpoint pen to etch (scratch) your design into the black paint.

6 Cut out your design, leaving a thin black border around all the shapes. Use PVA glue to stick the image onto a sheet of coloured card.

Paper cups

Painting paper cup animals, like these monkey designs, is great fun. Bold, simple shapes, limited detail and strong, vivid colours produce the most effective results.

Painting a curved surface

When painting the paper cup, put one hand inside the cup to hold it while painting with the other. Keep turning the cup round as you paint so you can see the monkey from every direction.

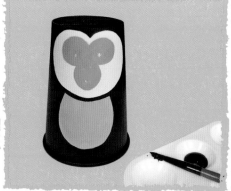

1 Pencil in a shape for the monkey's face. Add eyes, nose and mouth. Draw in shapes for the fur on its head and chest.

2 Paint these shapes using acrylic paints (as shown). Paint the rest of the cup black.

3 Now use a small paintbrush to paint in the eyes, nose and mouth. Add lines and dots to indicate the monkey's fur.

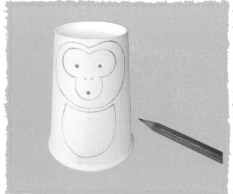
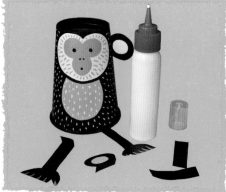
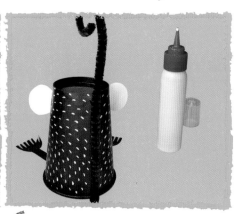

4 Draw simple shapes for its legs and ears on a sheet of paper. Paint them with acrylic paint. Cut out once dry.

5 Fold back the side of each ear and the top of each leg. Use PVA glue to stick them in place.

6 Use PVA glue to stick a pipecleaner 'tail' to the back of the paper cup. Bend the end into a curl.

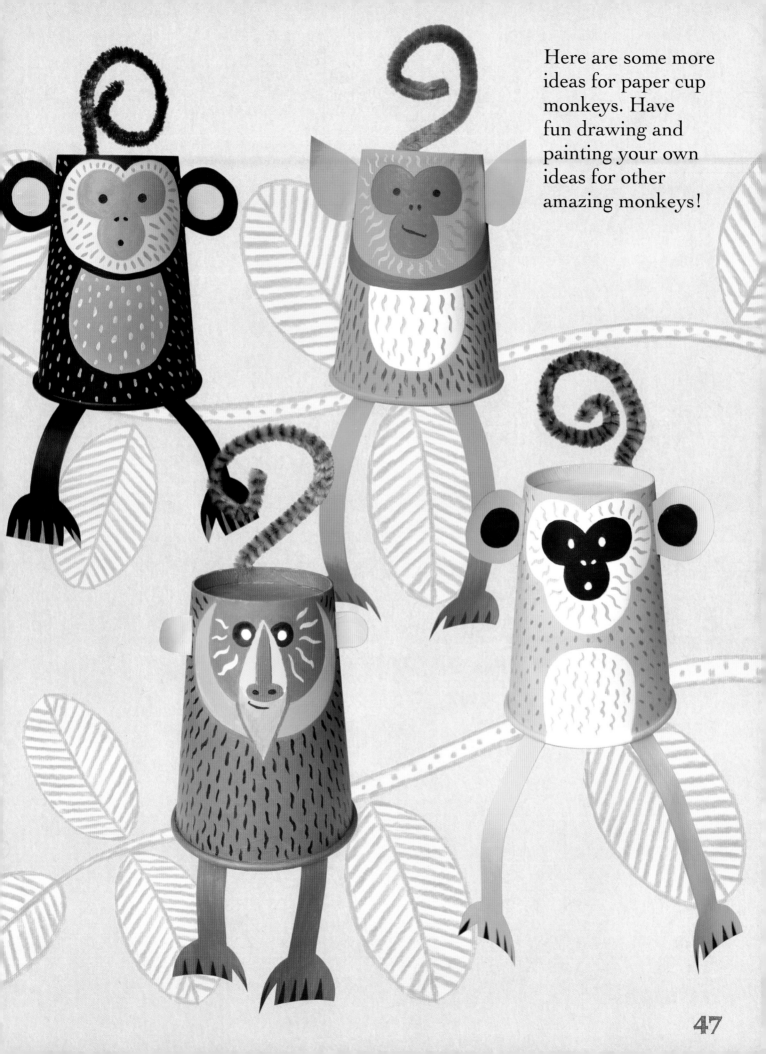

Here are some more ideas for paper cup monkeys. Have fun drawing and painting your own ideas for other amazing monkeys!

Drawing lions

First study the relationship between this group of animals. Look how close together they are and the differences in size between the animals. Check where each one is looking.

Construction lines

1 Pencil in three circles for the adult lion's head, chest and hind quarters. Add his tail.

2 Draw in lines for his forelegs and a hind leg. Use dots to indicate the joints. Add small ovals for the lion's large paws.

3 First check their size and position, before drawing two circles for each cub's head and body.

4 Draw in lines for their forelegs. Use dots to indicate the joints. Add small ovals for their paws.

48

5 Draw in the ears. Use construction lines to help draw the angle and shape of the lion's muzzle. The top of his nose is in line with the top edge of his ears. Draw in an eye.

6 Pencil in the shape of the lion's neck and body. Study the angle of his legs before drawing them in. Draw in both cubs.

7 Start adding detail to the lion's face. Note the angle of the teeth, then draw in his mouth, eye, nose and ears. Draw in his mane and add detail to his body, paws and tail.

8 Draw in the cubs' faces. Use construction lines to position their noses and mouths. Draw in the curved shapes of their ears, bodies, legs and feet.

49

Watercolour

Using washes to build tone

One of the key features of this painting is the way thinner washes of paint are layered to create shadow and to build up tone. The lightest layer is applied first, then subsequent layers are added as required.

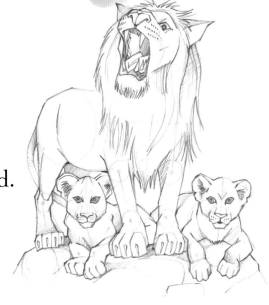

1 Finish drawing in all the details of the lion's head and mane. Add his claws. Draw in all the finishing details to the cubs' faces and bodies.

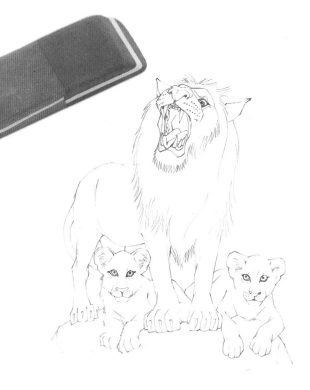

2 Carefully erase any construction lines from your finished drawing.

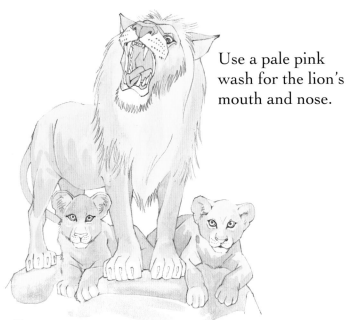

Use a pale pink wash for the lion's mouth and nose.

3 Use a paintbrush to apply the palest wash to the lion and cubs. Leave to dry. Add a slightly darker wash to create shadows and leave to dry. Add a pale grey wash to the rock, and blend in some yellow ochre to create a mottled effect.

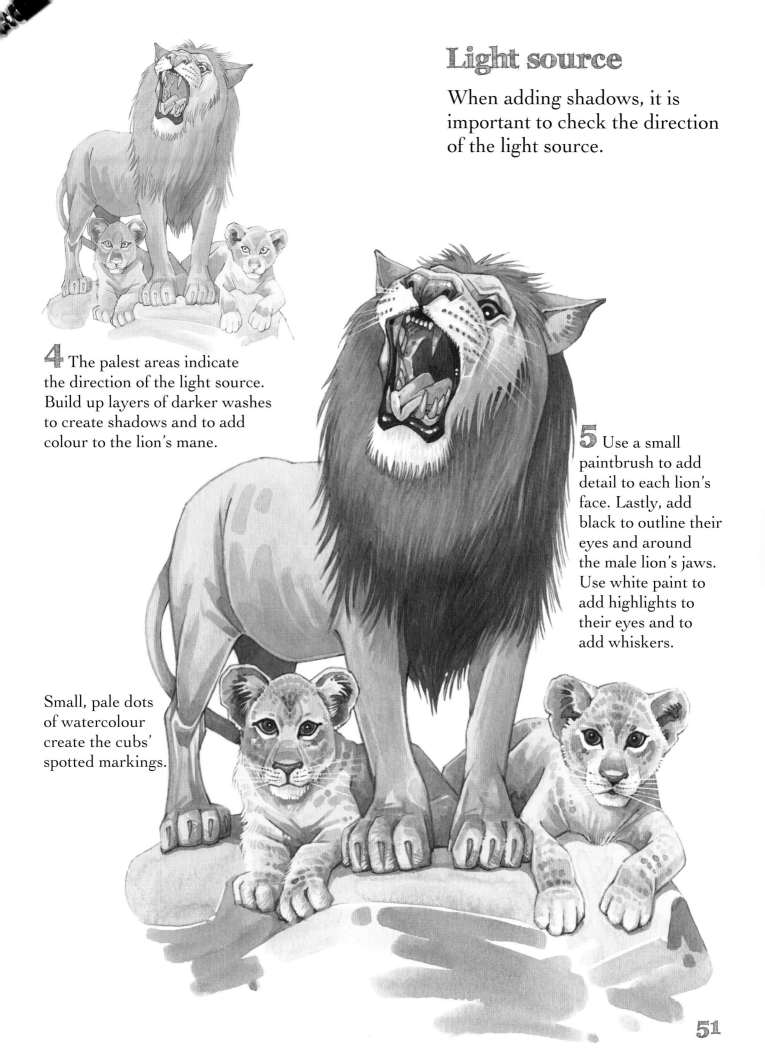

Light source

When adding shadows, it is important to check the direction of the light source.

4 The palest areas indicate the direction of the light source. Build up layers of darker washes to create shadows and to add colour to the lion's mane.

5 Use a small paintbrush to add detail to each lion's face. Lastly, add black to outline their eyes and around the male lion's jaws. Use white paint to add highlights to their eyes and to add whiskers.

Small, pale dots of watercolour create the cubs' spotted markings.

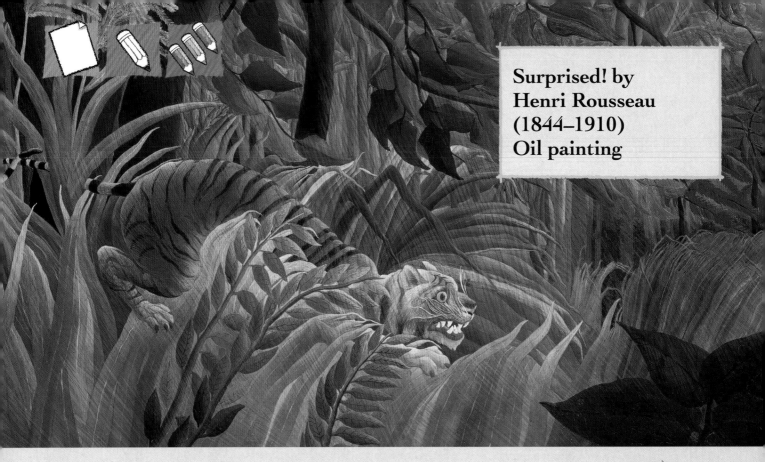

Surprised! by Henri Rousseau (1844–1910) Oil painting

Different style

In Henri Rousseau's wonderful painting of a tiger he shows it creeping through the jungle, hunting its prey. See how the tiger is camouflaged and almost hidden by the leaves and grasses. Study the painting and then draw your own version of a tiger in a jungle setting using Henri Rousseau for inspiration.

Henri Rousseau

Henri Rousseau is most famous for his richly-coloured and detailed paintings of jungles with wild animals.

A tiger creeping

1 Pencil in an oval for the tiger's body and two circles for its head and haunches.

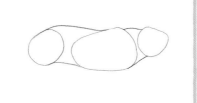

2 Add curved lines for the tiger's back, neck and underbelly.

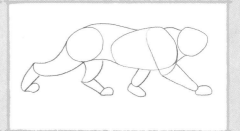

3 Draw in its front legs and feet. Note the angle of the back legs as you draw them.

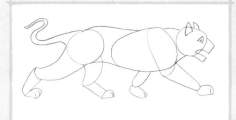
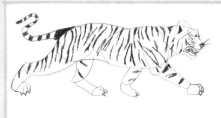

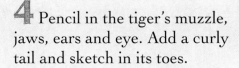

4 Pencil in the tiger's muzzle, jaws, ears and eye. Add a curly tail and sketch in its toes.

5 Using a black pencil crayon, carefully draw in the tiger's stripes. Don't forget its tail.

6 Pencil in tall grasses in the background. Add some more grass and leaves in front of the tiger.

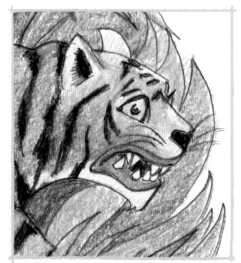

7 Use pencil crayons to colour in the background. Colour in the tiger's face, paying special attention to its snarling mouth and the eye looking onto its prey. Finish by crayoning in the tiger's fur, leaving its underbelly paler.

If you want your tiger drawing to stand out, use a black pencil crayon to outline its shape.

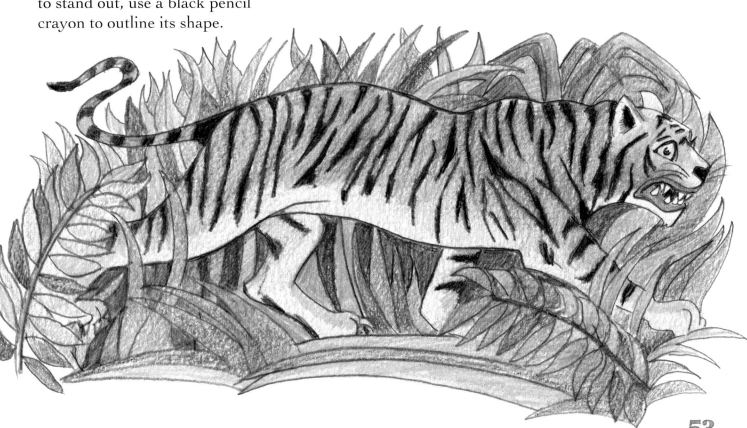

Movement

Different positions

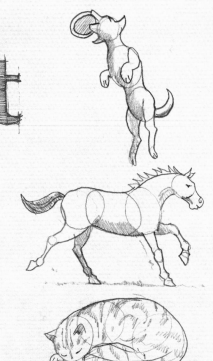

Animals come in all shapes and sizes, so they use a wide range of different movements when they relax, walk, run, jump or climb. Here are some examples showing animals in different positions for you to use as reference. Try doing some quick sketches of your favourite animals in action.

Elephant

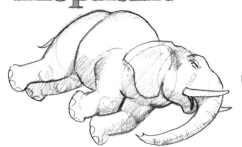

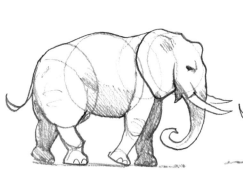

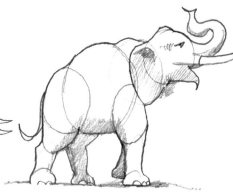

Sleeping **Walking** **Trumpeting**

Panda

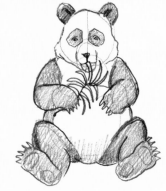

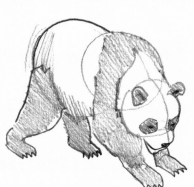

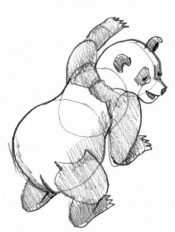

Sitting **Walking** **Climbing**

Horse

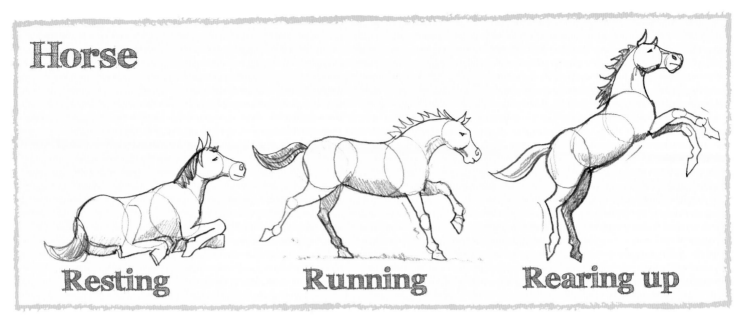

Resting **Running** **Rearing up**

Chicken

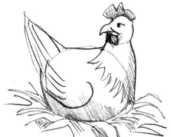
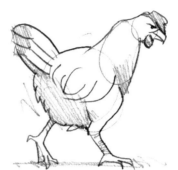
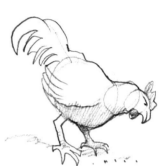

Sitting **Walking** **Pecking**

Cat

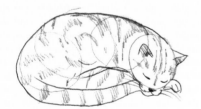
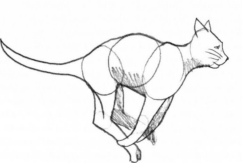
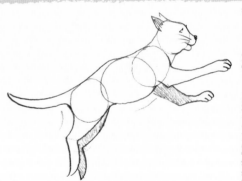

Sleeping **Running** **Jumping**

Dog

Resting **Running** **Jumping**

Computer

Drawing on a computer is fun. Experiment using lots of different shapes, colours and textures. Most types of computer have a drawing programme of one kind or another. You can also download some fantastic drawing and painting apps onto various tablets and smartphones, free of charge.

Tools

These are the sort of tool icons you will find on the screen. Touch them all in turn to experiment with the different effects you can achieve using each one of them.

Colours

To change colours, touch the one you want to use.

Tablet or smartphone

1 Draw in a lion with your fingertip, using the pencil or crayon tool. Select a colour to draw in its mane. Now change colours to draw in the face and ears.

2 Choose darker colours to draw in its nose.

3 Use different drawing tools to add finishing details to its face and mane.

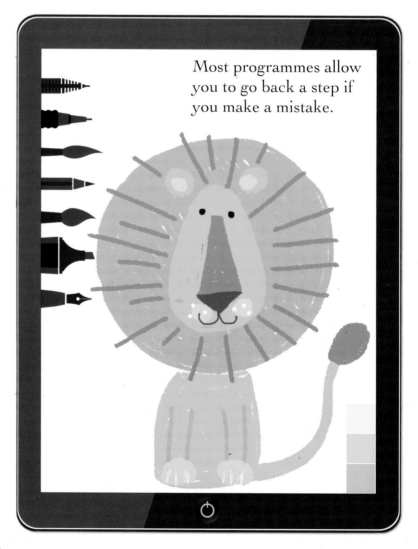

Most programmes allow you to go back a step if you make a mistake.

4 Remember to keep saving your drawing as you work.

Draw in the lion's body, front legs, paws and long tail.

Using a computer

Choose a graphic software package that comes with a set of art tools that mimic pens, pencils, paintbrushes and paints. Many of these are available free of charge.

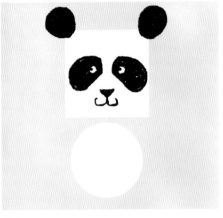

Follow the instructions to create a blank document. Start by choosing a simple tool like a pencil. Use the mouse (or a digital pen if you have one) and try doodling with the different tools.

1 Most programmes have tools to create basic shapes. Click on the paint box tool to fill the background with pale brown. Select white and draw a square for the panda's head and a circle for its body.

2 Click on black, then use a drawing tool to draw in its ears, eye-patches and nose. Click on white and draw in small circles for the eyes. Add small black dots to the eyes.

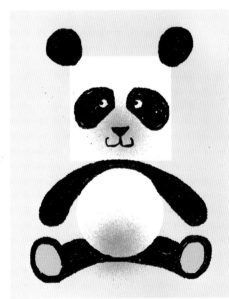

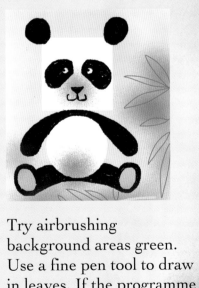

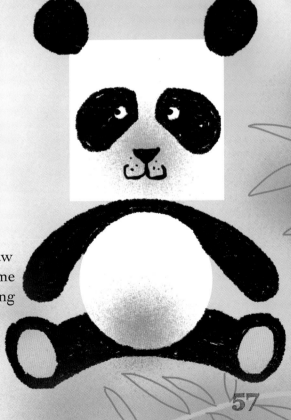

3 Draw in the arms, legs and feet. Add small grey pads to its feet. Use the airbrush tool to add a smudge of grey to its nose and belly.

Try airbrushing background areas green. Use a fine pen tool to draw in leaves. If the programme has the option for changing the 'hue and saturation', try altering your colour scheme. It will totally transform your drawing.

Inspiration 1

Whenever you get the opportunity, visit art galleries and museums to see how other artists draw and paint animals. Collect postcards that appeal to you of animals drawn and painted by famous artists. Ask yourself what you like about their work. Is it the colours they use? Is it the way they make marks, or is it the materials or techniques they have chosen? These final pages show a selection of drawings and paintings that show the different ways that some artists have depicted animals.

**Blue Horses
by Franz Marc
(1880–1916)**

Marc is most famous for his paintings of brightly-coloured animals, especially horses. (Oil painting.)

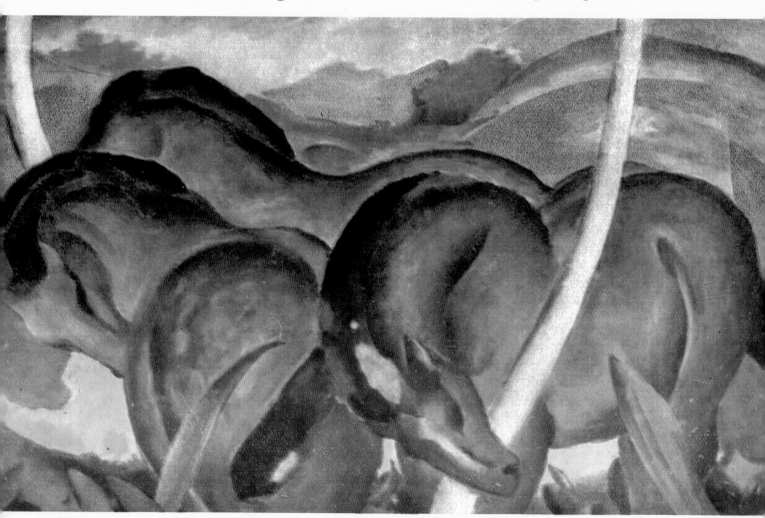

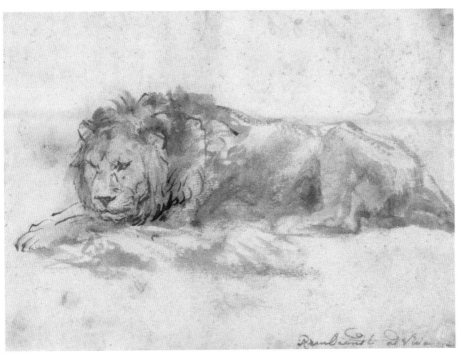

Reclining Lion
by Rembrandt van Rijn
(1606–1669)

Rembrandt was 46 years old when he saw a lion for the first time. He made drawings of lions in his sketch books for later use in paintings. Rembrandt was known as an artist who liked to draw from life.
(Pen, ink and wash on paper.)

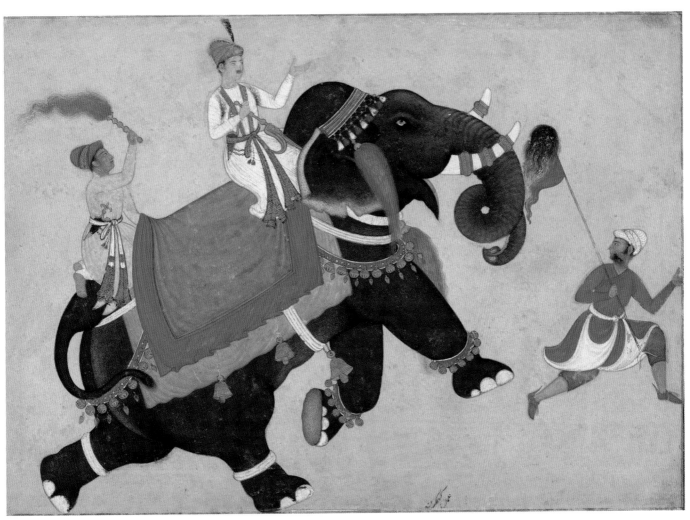

Prince Riding an Elephant
by Khem Karan
(c. 1580–c. 1605)

Elephants were an important part of Mughal life. They were used for war, entertainment and travel.

Elephants were often drawn and painted by the artists of the Mughal Empire in India.
(Watercolour.)

Inspiration 2

Mouse
by Albrecht Dürer
1471–1528

Dürer was one of the first artists to be interested in drawing and painting animals.
(Pen and ink on paper.)

As the work of these artists shows, there is no right or wrong way to draw and paint animals. Each artist has developed a style and technique that suits them best. Practise by drawing your own (or friends') pets, and if you can't draw from life, try sketching from photographs of animals.

Monkey and bug
by Ohara Koson
(1877–1945)

Koson's work was mainly of birds, flowers and animals. His use of pale, subtle colours gave his prints the appearance of being watercolour paintings. (Woodcut print.)

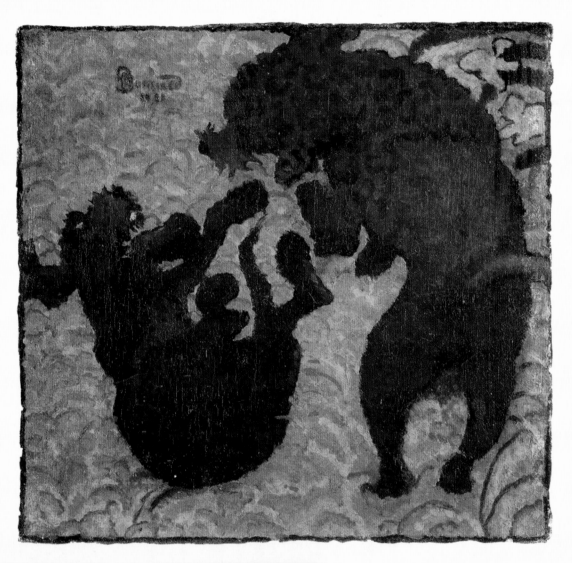

Two Poodles
by Pierre Bonnard
(1867–1947)

Bonnard was very fond of cats and dogs and regularly drew and painted them. He made two sketches of his poodle, which he used for this composition. (Oil paint.)

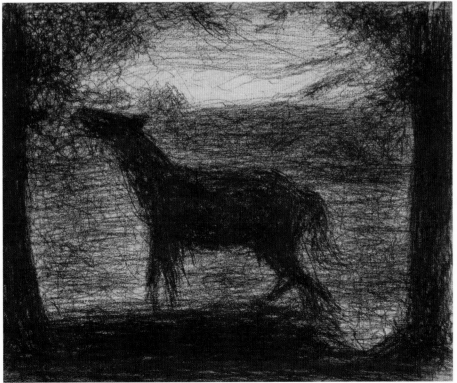

Foal
by Georges Seurat
(1859–1891)

Seurat used scribbled lines to draw this silhouette of a foal. (Conté crayon on coloured paper.)

Glossary

Background The part of a scene that is behind or around the main object in an artwork.

Bleed The visual effect achieved when a dark colour seeps into a lighter colour.

Burnish To use a tool to rub smooth a surface.

Collage A technique used to create a work of art in which pieces of paper, photographs, fabric and other items are arranged and stuck down onto a surface.

Colour scheme The selection of colours used in a design for a range of media.

Composition The arrangement of the main parts of an image so as to form a unified whole.

Construction lines Pencil lines used as guides when sketching or drawing.

Design A graphic representation, usually a drawing or sketch.

Etch A technique that uses incised or scratched lines to form the image.

Indenting The use of a blunt instrument to indent lines on paper, which show white after crayoning.

Light source The direction from which light shines.

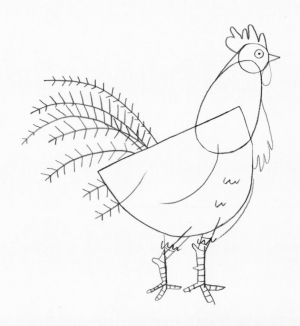

Origami The art or process of folding squares of paper into representative shapes.

Relief printing The technique of cutting or etching a printing block so that the surface that remains is the design to be printed.

Shading The lines an artist uses to represent gradations of tone.

Squaring-up technique The use of a grid to enlarge a drawing to a fixed scale or proportion.

Stencil A sheet of paper or card with a cutout design, so that when paint is applied to it the design will transfer to the surface beneath.

Tone The lightness or darkness of a colour.

Watercolour (or ink) wash A layer of diluted watercolour (or ink) painted across the paper.

Wax resist A waxy medium used to block out part of the paper so watercolour will not stick to it.

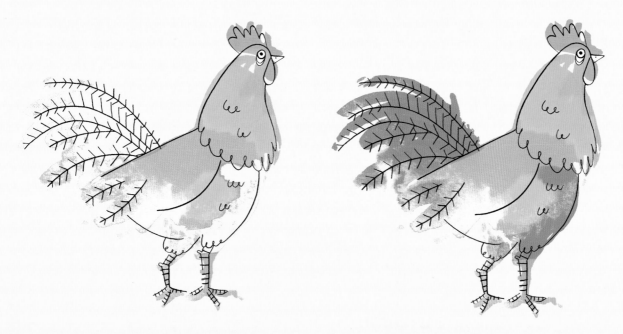

Index

A

acrylic paints 4–5, 20, 39, 46

B

background 9, 11, 13, 21, 42, 44, 53, 57, 62
bleed 22, 25, 62
Bonnard, Pierre 61
burnish 33, 62

C

collage 16, 34, 62
computers 56–57

D

Dürer, Albrecht 60

E

etching 5, 44–45, 62–63

G

Gaudí, Antoni 40

H

handprints 18–19

I

indenting 26–27, 32–33, 44, 62

M

mosaic 40–41
movement 54–55

O

origami 30, 63

P

paper cups 4, 46–47
photographs 16, 42–43, 60, 62

R

relief printing 5, 32–33, 63
Rijn, Rembrandt van 59

S

Seurat, Georges 61
shading 4, 8, 29, 43, 50–51, 63
squaring-up 42–43, 63
stencil 36–37, 63

T

tissue 34–35
torn paper 26–27

W

washes 5–7, 11, 13, 24 25, 50–51, 59, 63
watercolours 5–7, 11, 22, 24, 50–51, 59–60, 63
wax resist 5, 12–13